IMAGES
of America
ST. LOUIS
GARDEN DISTRICT

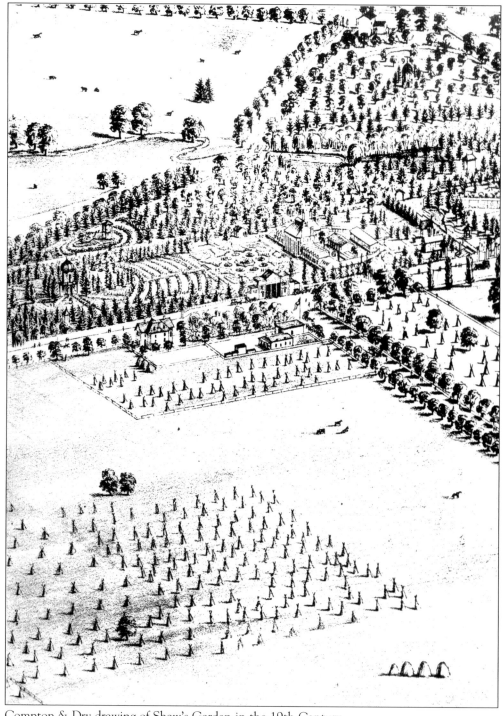

Compton & Dry drawing of Shaw's Garden in the 19th Century.

IMAGES
of America

St. Louis
GARDEN DISTRICT

Albert Montesi and Richard Deposki

ARCADIA

Published by Arcadia Publishing,
Charleston SC, Chicago IL, Portsmouth NH, San Francisco CA

Printed in Great Britain.

Library of Congress Catalog Card Number: 2004104015

For all general information contact Arcadia Publishing at:
Telephone 843-853-2070
Fax 843-853-0044
E-Mail sales@arcadiapublishing.com
For customer service and orders:
Toll-Free 1-888-313-2665

Visit us on the internet at http://www.arcadiapublishing.com

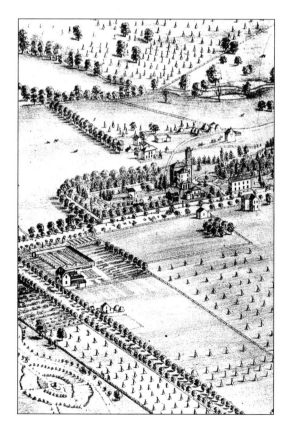

A 19th century Compton & Dry drawing of the southern edge of Shaw's Garden and a portion of Tower Grove Park.

CONTENTS

ACKNOWLEDGMENTS

We would like to thank the following for their kind help in the making of this book:

Barbara K. Beals and Ann Boston (Missouri School for the Blind)
Caroline Dohrenhorf
Walter Eschbach
Michael and Emily Grady
Richard Gruss
Jefferson National Expansion Memorial, NPS
Jennifer L. Rawlings
Dan Krasnoff
Kathy Kuba
Metropolitan Sewer District, Frank E. Janson
Missouri Botanical Garden Archives, Andrew Colligan
Bob Nicolay
St. Louis University Archives
St. Louis Public Schools Record Center/Archives, Sharon A. Huffman and Gloria Harris

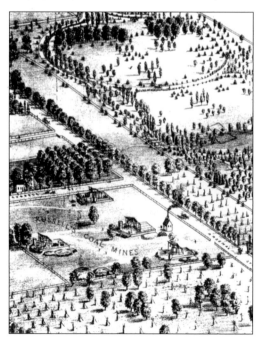

A 19th century Compton & Dry drawing of the western portion of Tower Grove Park and the area to the south.

INTRODUCTION

We have selected the title *Garden District* for this text to designate what makes up several segments of present-day South St. Louis. These districts were all hewed out of the common lands of the so-called "Prairie des Noyers" tract (Meadow of the Walnut Trees), which lay southwest of early St. Louis. The land was purchased at this time by several people, but ended up in the hands of Mary Lawrence Tyler and the philanthropic Henry Shaw. Mary Tyler sold her property to developers, but Henry Shaw not only made his home in the area, but built his famous garden and park within it.

It was mainly Shaw's creation of his famous botanical garden and his Victorian Tower Grove Park that drew developers and homeowners to the vicinity. The districts that we will cover in this pictorial essay all developed around the garden and the park. They presently include the Shaw neighborhood, Oak Hill, Compton Heights, Compton Hill Reservoir Square, Tower Grove East, Tower Grove Heights, and Compton Hill.

Before we provide a historical account of the Garden District and its growth, decline, and development, it would be of some importance to survey, however briefly, these various neighborhoods and their location in the larger spread of the Garden District. There were, of course, several other factors that contributed to the growth of South St. Louis and the area at hand, but Shaw's cultivation and influence seems a central one.

THE SHAW NEIGHBORHOOD. Bound by Kingshighway Boulevard and Grand Avenue, this stretch of property includes the world-famous garden and elegant park. It also includes, of course, the Shaw homes that have been built upon it—the country home and the town residence that was moved from downtown St. Louis to its present location in the garden. We must not omit that stretch of land that soon became known as Flora Place, whose street provided an entrance to the elaborate front gates of the botanical garden.

SHAW PLACE. This tiny group of houses, built in a humble, but charming manner, represented Shaw's desire to build close to Grand Avenue. It was eventually owned by the garden and the rent collected from these homes provided the early garden with maintenance funds. However, eventually the administration at the garden sold the lot to private developers.

OAK HILL NEIGHBORHOOD. Oak Hill Neighborhood has great historical significance in the growth of St. Louis. It not only contains a main artery, Gravois Avenue, but a career that includes a coal vein and a salt spring. It can be roughly mapped as existing between Arsenal Street and Kingshighway Boulevard. Commerce was pioneered in this stretch of land, since on it grew the now busy segments on "Grand Grand Avenue," and the "road to Fenton."

COMPTON HILL RESERVOIR SQUARE. When the city built a giant reservoir containing tons of water to supply the needs of most of South St. Louis, it created a park area that surrounded the large structure. On it, the city built an imposing water tower and a excellent, carefully landscaped park.

COMPTON HILL. Within Compton Hill's environs stood the giant reservoir, its tower, and the park, and later an affluent subdivision called Compton Heights.

COMPTON HEIGHTS. This subdivision was an enclave of richly constructed houses, built generally by successful German businessmen in the 1890s, and covering principally two streets—Hawthorne and Longfellow. Platted by Julius Pitzman in 1884, he determinedly designed his streets as curvilinear to avoid traffic and noise.

TOWER GROVE HEIGHTS. This area off Grand Avenue, with streets such as Hartford and Connecticut, is a neighborhood of modest homes and middle-class respectability. Its streets are named after officials of the Hartford Insurance Company, which started in the area.

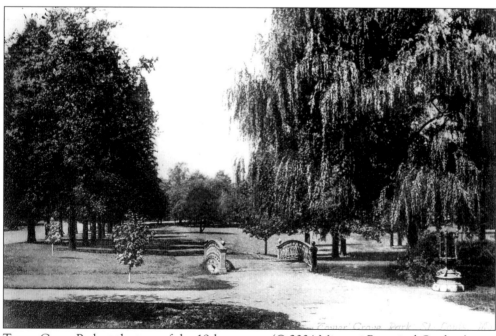

Tower Grove Park at the turn of the 19th century. (© 2004 Missouri Botanical Garden.)

One
BEGINNINGS

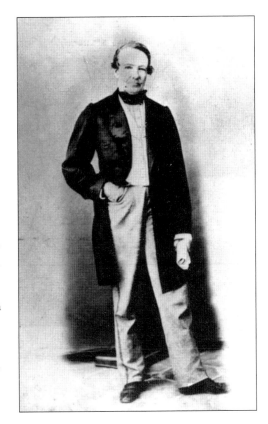

Amongst the personalities that graced the St. Louis stage in the 19th century, Henry Shaw outshone all others. He has, by the dint of his generosity to the city and his excellent eye for its future, become in our day almost mythic in stature. He has in ways large and small been instrumental in providing the city with the now world-famous Shaw's Garden, in addition Tower Grove Park, Washington University's Department of Botany, and several schools in the district surrounding the garden. In covering the Garden District and its environs, we are in fact covering the ongoing presence and spirit of this great man. (c. 1858, © 2004 Missouri Botanical Garden.)

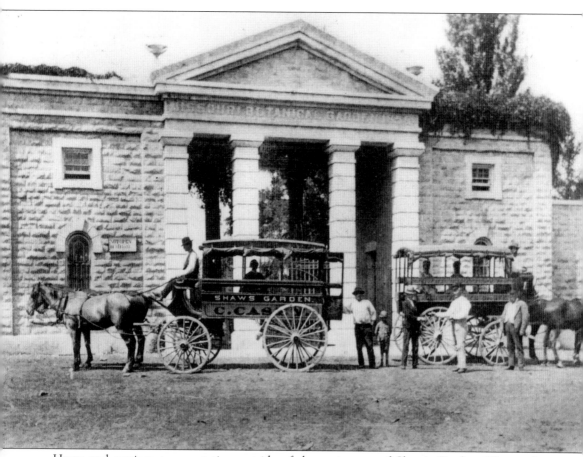

Horse and carriage transportation outside of the main gate of Shaw's Garden. This is the original elaborate entrance from Floral Place, now called Flora Place. Having emigrated from England, Henry Shaw arrived in St. Louis in 1818 and after a period of stinting and privation had gradually amassed a fortune. Retiring at forty, he visited Europe where he traveled a year or more spent generally in viewing the great classical art centers and particularly the eminent public gardens of various cities. Foremost, among these, was the famous London's Kew Gardens. When he returned he acquired vast plots of real estate in the southwest perimeter of the city, which at that time ended at Grand Avenue. Attracted by the foliage of grasses and trees that grew there and by the beauty of the landscape, he found the area so delightful that he soon built a country home on the present vicinity of the Garden. There with the encouragement of the director of Kew Gardens, W.J. Hooker and George Englemann, he soon mapped out a plot of land for his public garden venture. (© 2004 Missouri Botanical Garden.)

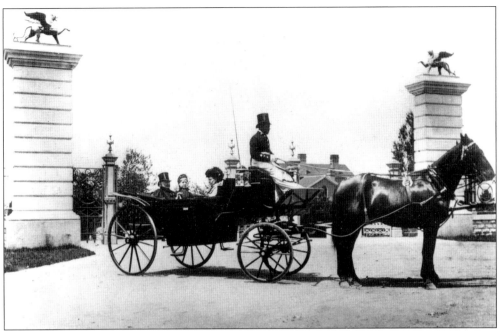

Pictured here is a photograph of Henry Shaw and his sisters in their carriage in the 1880s. They are in front of the entrance to Tower Grove Park at Grand Avenue. Since Shaw never married, a good deal of his property was inherited by his family. (© 2004 Missouri Botanical Garden.)

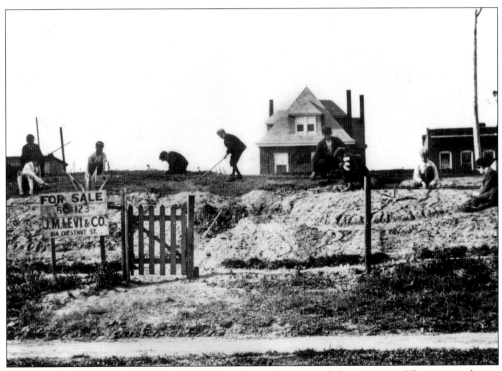

A view of construction in the neighborhood at the turn of the century. The area is being prepared for the erection of a new house. (© 2004 Missouri Botanical Garden.)

This is Kingshighway Boulevard at the end of Tower Grove Park at the turn of the 20th century.

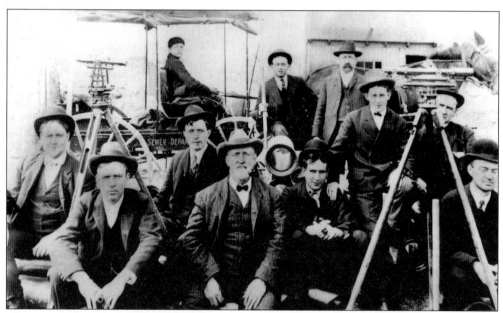

The matter of creating these new subdivisions was not some simple task of laying out streets and sewers. Great financial expenses and technological care were needed and provided by the creation of the Manchester Road Joint Sewer District. This venture provided the sewer district with a method by which expenses would be shared by the building homeowner and the district. Pictured here are various members of the organization that provided engineering and other skills for these undertakings. (MSD.)

Two
MISSOURI BOTANICAL GARDEN
SHAW'S GARDEN

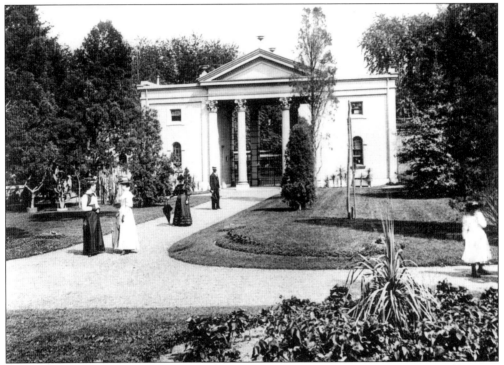

Looking east at the turn of the 20th century, visitors gather to chat at the walks that ribbon out from the main gate. From the very beginning, efforts were made to develop the garden into a tract of endurable beauty. Here, we have a glance of the classically styled main entrance, which then fronted on Flora Place in *c.* 1900. Shaw had acquired a great deal of the old Noyer tract from land owners like Mary Tyler and others. At about this time, he brought in his favorite architect, George I. Barnett, to build not only a townhouse in the center of the city, but also a Florentine villa in the grounds that he called Tower Grove. Determined then to create a public garden in the area surrounding his country home, he—with the aid of leading botanists of the country, the director of Kew Garden, and George Engelmann—collected herbariums, species of plants and trees, and a collection of books for a library. He then had Barnett create certain buildings to house his species. Soon this tract of shrubs, plants, and trees began to attract the citizens of St. Louis, who visited there in great numbers. From its early 20th century setting, we can readily determine how monumental and graceful the Garden had become in a relative few years. (© 2004 Missouri Botanical Garden.)

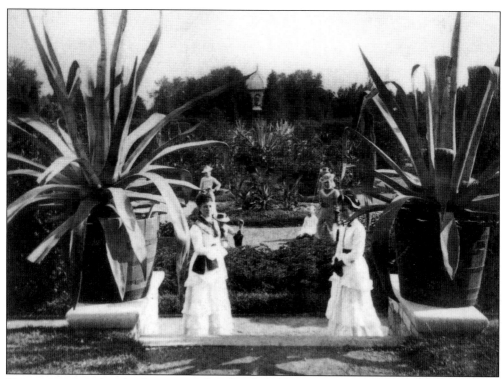

Two women pose beside plants twice their heights. (© 2004 Missouri Botanical Garden.)

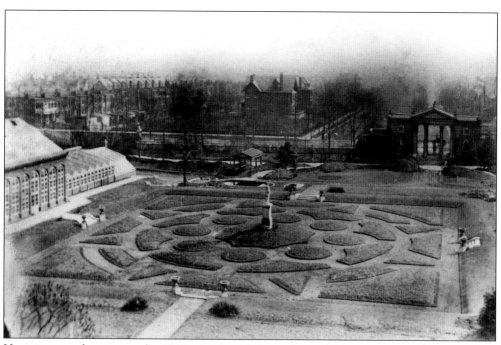

Here is an early parterre (c. 1912-1913) with boundaries mapped out with precision and symmetry. These parterres, with their carefully designed outlines, were a delight of the period. (© 2004 Missouri Botanical Garden.)

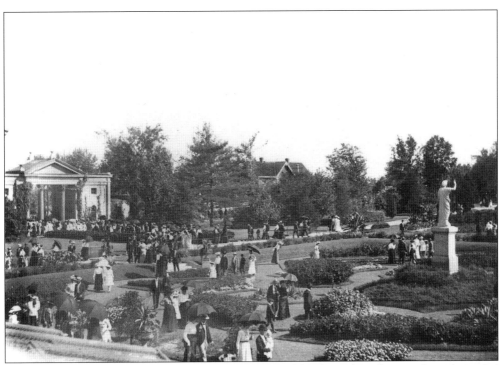

The popularity of the garden can be readily determined by the rush and press of people in this turn of the 20th century photograph. (Missouri Botanical Garden Archives.)

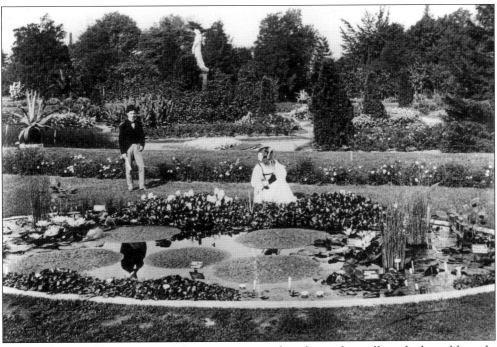

Here we have a glance at one of the exotic species that the garden collected—huge lily pads. This is an 1890s photo, looking west. (© 2004 Missouri Botanical Garden.)

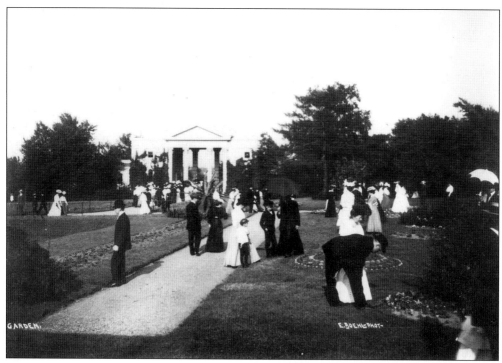

Here again, as the 19th century turned, visitors crowded the garden's walls. (© 2004 Missouri Botanical Garden.)

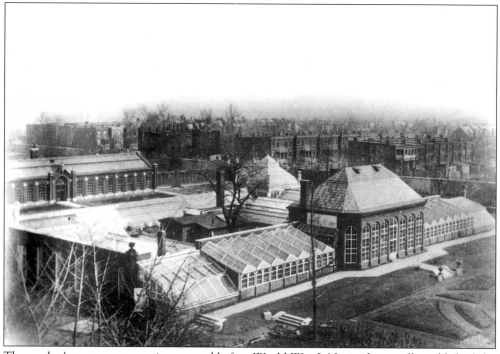

The garden's conservatory as it appeared before World War I. Notice how well established the garden's quarters had become. (© 2004 Missouri Botanical Garden.)

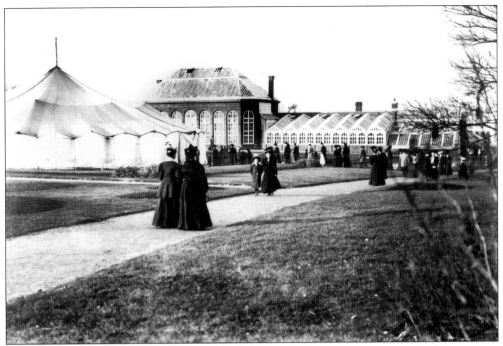

Here indeed is a vignette of the times—with the garden's conservatory as a backdrop, long-garmented women stroll about the garden paths. (© 2004 Missouri Botanical Garden.)

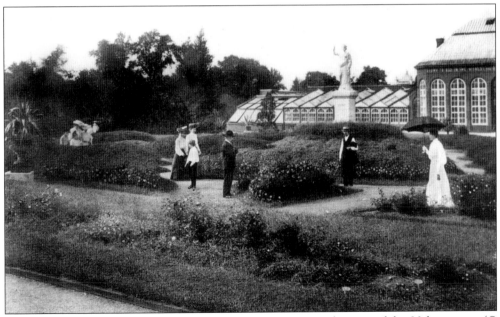

A statue of Juno protects the entrance to the conservatory at the turn of the 20th century. (© 2004 Missouri Botanical Garden.)

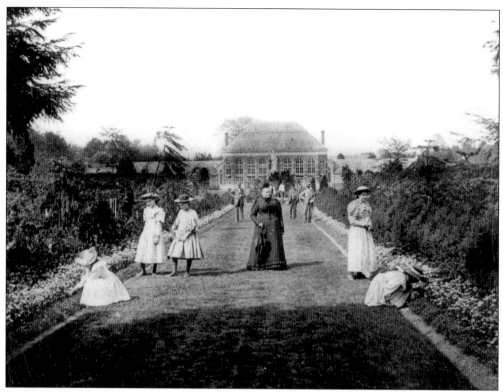

Here a family strolls through the park at the turn of the 20th century. The children stop to examine the flora near the conservatory. (© 2004 Missouri Botanical Garden.)

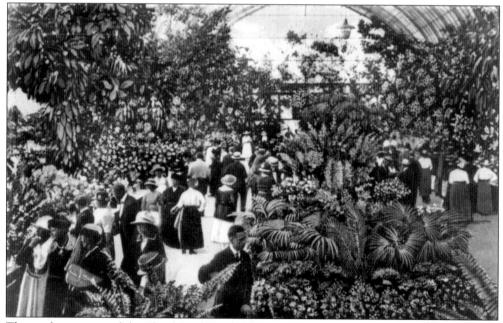

This is the interior of the Floral Display House that later burned down in 1978. (c. 1915, © 2004 Missouri Botanical Garden.)

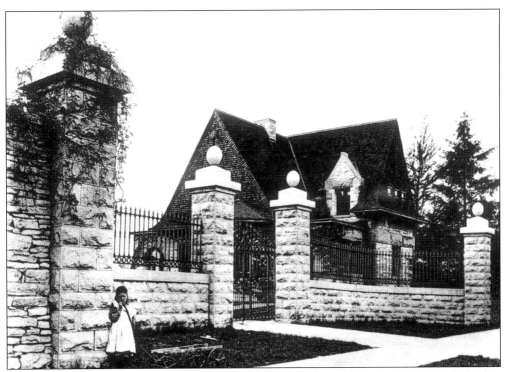

This is the Cleveland Avenue entrance to Shaw's Garden. Notice the wrought-iron conjoined to the stone structure. Notice too the semi-classical design of this gateway, a design that characterizes several of the buildings in the garden. (*c.* 1898, © 2004 Missouri Botanical Garden.)

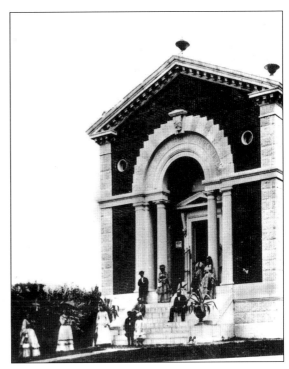

Classical columns, a pitched roof, and arches characterized the museum in 1867. It remains the same today. (© 2004 Missouri Botanical Garden.)

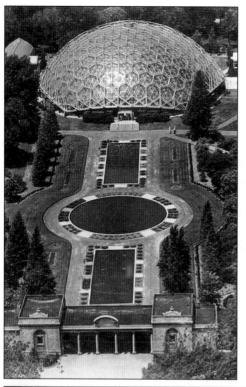

Central to the garden and acting as its major focal point is the world-famed Climatron, which houses an amazing circular walk of tropical and subtropical plants. During the decades before and after World War II, the garden went into somewhat of a decline. But with the introduction of the Climatron, and later the famed Japanese Garden, attendance soared. Here we see the aesthetically alluring, patterned design of the entrance to the dome. (*c.* 1960s, © 2004 Missouri Botanical Garden.)

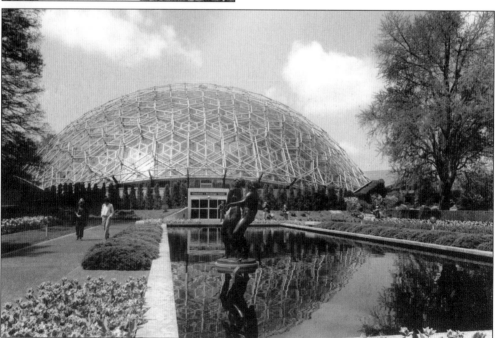

This is the geodesic dome as it appears from the walks and ponds leading to its entrance. This bold stroke of architectural innovation was supervised in its making by Murphy and Mackey, architects of St. Louis, and erected in 1958–1959 and opened in 1960. It was, of course, patterned after the creations of Buckminister Fuller.

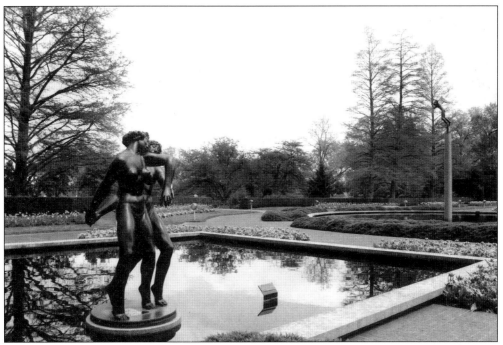

Two mythic statues by Carl Milles grace the grand entrance to the dome.

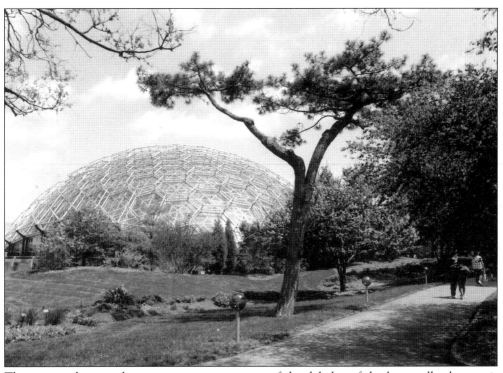

This recent photograph manages to capture some of the delights of the lane walks that await those who visit the garden.

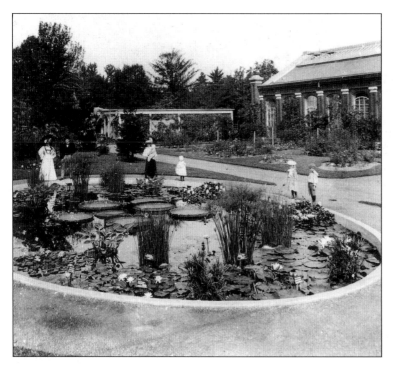

One of the species of flowers, called Victoria Regia, that the garden has successfully grown. (© 2004 Missouri Botanical Garden.)

A stereo opticon of the 1890s captures a double view (the two photos in a special viewer creates a 3-D image) of lily pads positioned before the famed Linnean House, the first greenhouse of its kind in the United States. This species, called Victoria Nyanza, was strong enough, as we can see, to carry the weight of this little girl. (© 2004 Missouri Botanical Garden.)

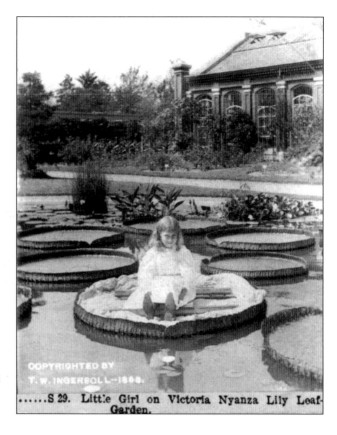

COPYRIGHTED BY
T. W. INGERSOLL—1898.

......S 29. Little Girl on Victoria Nyanza Lily Leaf-Garden.

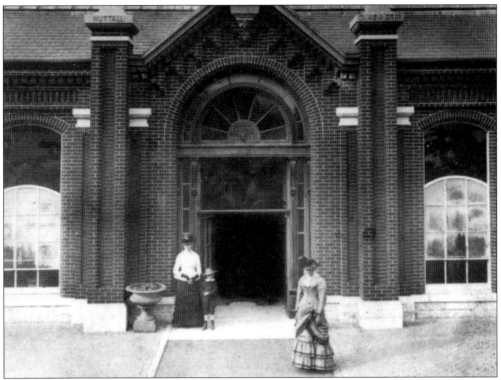

This is the main entrance to the Linnean House at the turn of the 20th century. (© 2004 Missouri Botanical Garden.)

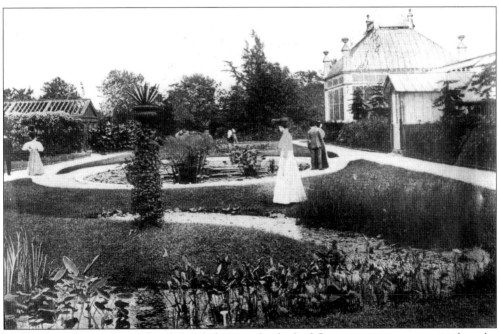

Looking northwest, somewhat behind the circular bed of flowers, we can see an early palm house at the turn of the 20th century. (© 2004 Missouri Botanical Garden.)

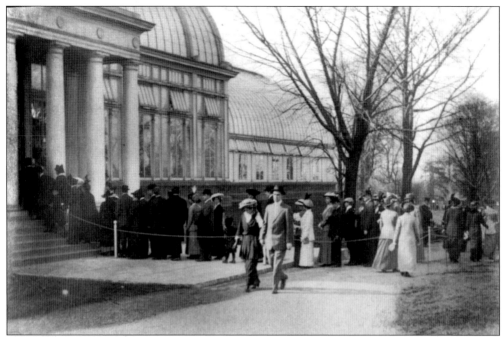

Rows of visitors line up to enjoy the sight of tropical plants in the popular Palm House. (c. 1913, © 2004 Missouri Botanical Garden.)

Guests often took pictures of themselves as they walked through the garden. Here, in what appears to be a family gathering, these couples pose in the garden. This photo was taken in the Italian Garden in the 1920s and we can see that the women no longer wear long garments.

Here, park gardeners busy themselves tending their plants in this 1880s photograph. (© 2004 Missouri Botanical Garden.)

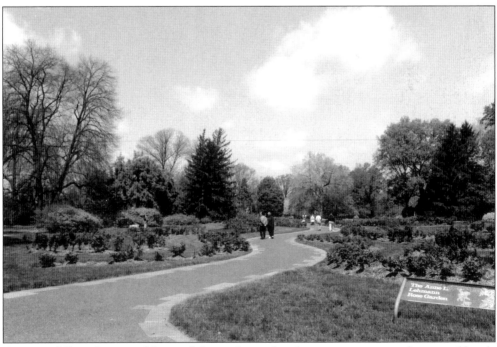

As guests follow the curved lanes of the garden paths, they encounter row after row of lovely growing plants. (© 2004 Missouri Botanical Garden.)

Here is the garden in a blaze of glory, as its plants blossom in a recent spring.

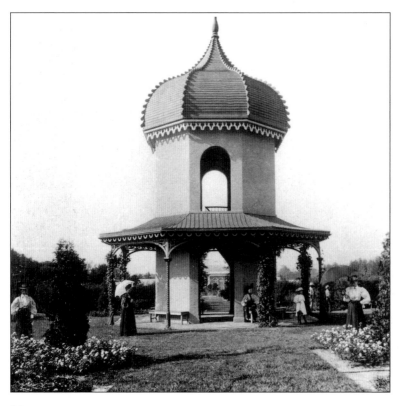

This domed-shaped observatory stood on the garden's grounds at the turn of the 20th century. (© 2004 Missouri Botanical Garden.)

A closer view of the observatory as it is enjoyed by guests. It was built before 1875. (© 2004 Missouri Botanical Garden.)

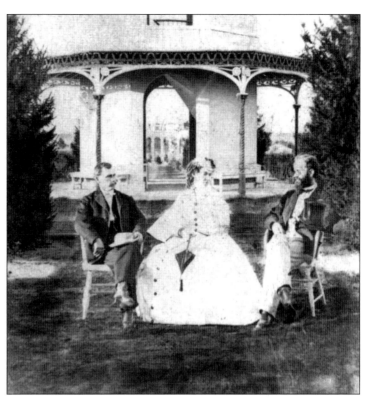

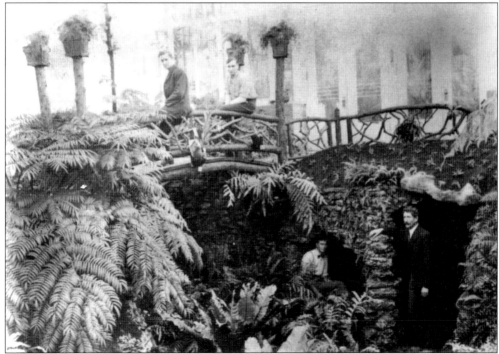

Before the erection of the great Climatron, tropical plants were nurtured in appropriate temperature-controlled greenhouses, such as the Palm House.

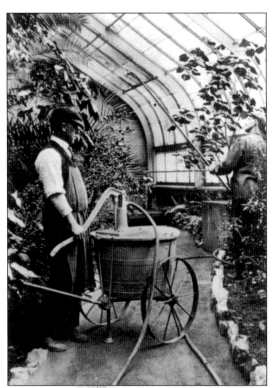

Here, we get a look at a hand-operated water pump employed to feed the hungry plants. This photograph was taken in the early 20th century.

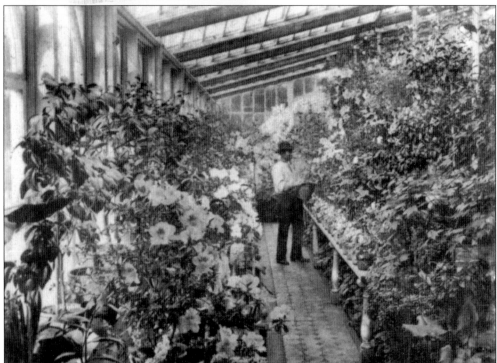

In this 1880s scene, we can see a worker tending his charges in the Conservatory. (© 2004 Missouri Botanical Garden.)

Here is another example of how carefully the garden took care of its exotic rain forest plants. This is an1870s interior view of the Conservatory (© 2004 Missouri Botanical Garden.)

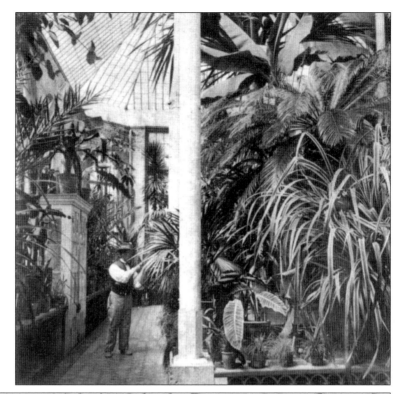

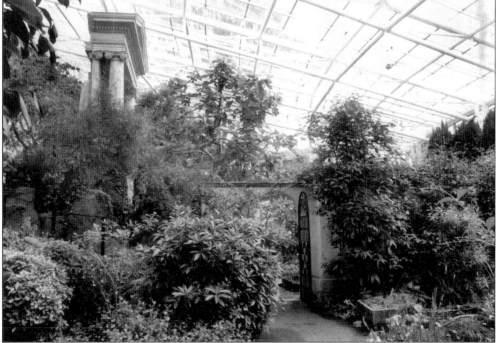

A breathtaking view of a nook with a temple-like building in front, which exists within the Temperate House. Here, a scene of idyllic beauty, encased in a tiled entrance and including the classical columns, greets the charmed visitor.

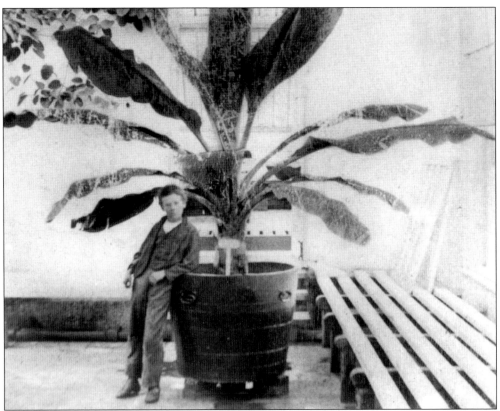

Here, a young lad poses before an enormous palm inside a greenhouse in this turn of the century photo. (© 2004 Missouri Botanical Garden.)

At his death and as his will so requested, Henry Shaw's townhouse was moved to its present site on the grounds of the garden.

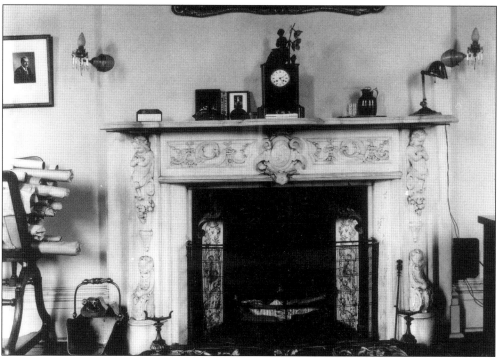

The mantle and fireplace stand out in the northeast room of Henry Shaw's townhouse. (*c.* 1940, NPS.)

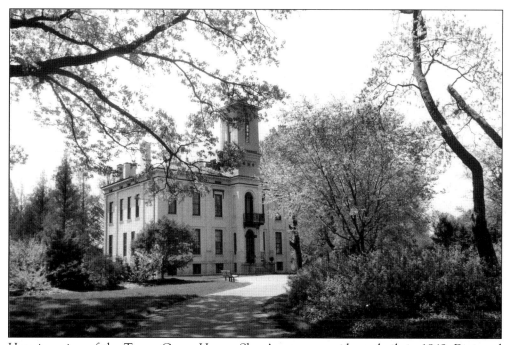

Here is a view of the Tower Grove House, Shaw's summer residence built in 1849. Designed after an Italianate villa by George I. Barnett, it manages to still attract visitors with its charm and elegance.

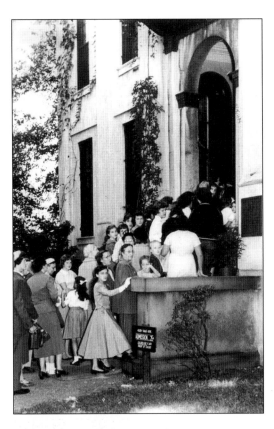

Here, visitors crowd up to view the interior of the Tower Grove House in the 1950s. (© 2004 Missouri Botanical Garden.)

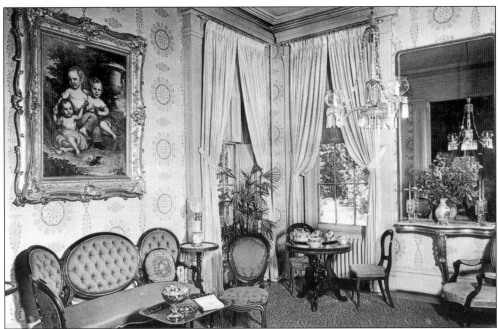

We see here the Tower Grove front parlor, with its period furniture carefully maintained. (c. 1950, © 2004 Missouri Botanical Garden.)

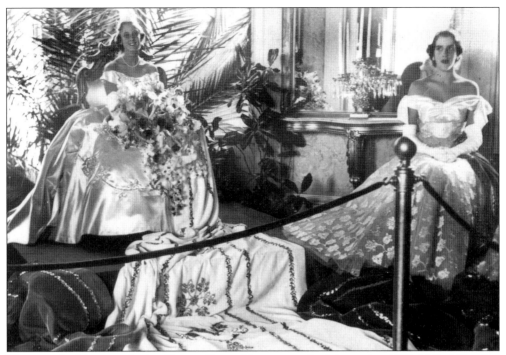

Photographed here with the Tower Grove House as a backdrop, the 1953 Veiled Prophet Queen and one of her maids of honor. At that time the Veiled Prophet ball and parade were spectacular St. Louis social and cultural events. (© 2004 Missouri Botanical Garden.)

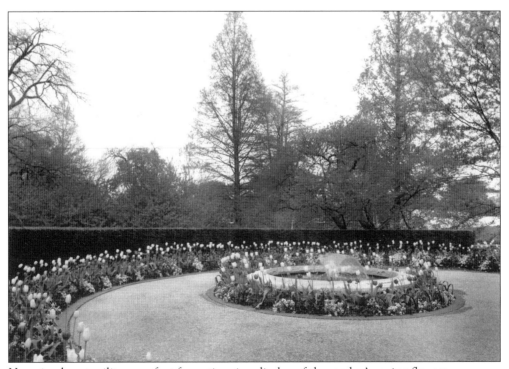

Here, in almost military-perfect formation, is a display of the garden's spring flowers.

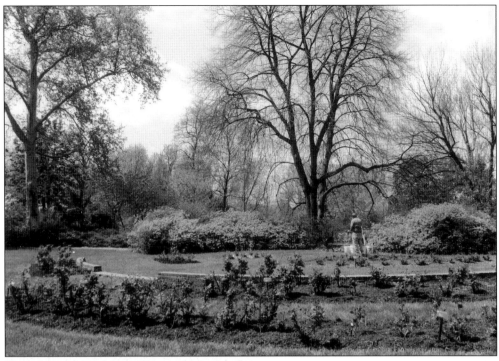

Here, we see a worker tending to the spring flowers.

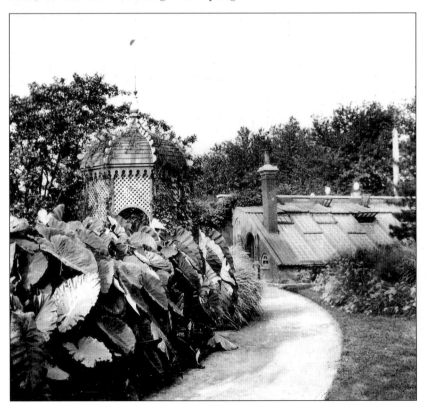

Again, a vintage snapshot from the turn of the century. Here, we see an early greenhouse.

Barnett also designed Shaw's elegant mausoleum, with a sarcophagus sculpted by Frederick von Mueller of Munich. (c. 1910, © 2004 Missouri Botanical Garden.)

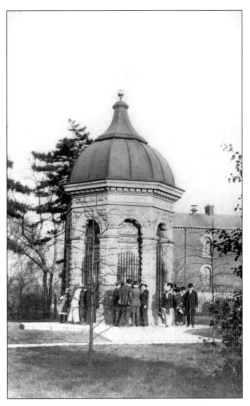

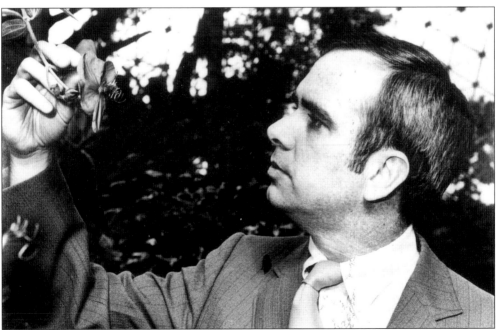

Dr. Peter Raven, director of the Missouri Botanical Garden, by dint of his care and devotion to the health of the planet, has become an internationally known botanist and environmentalist. (c. 1972, © 2004 Missouri Botanical Garden.)

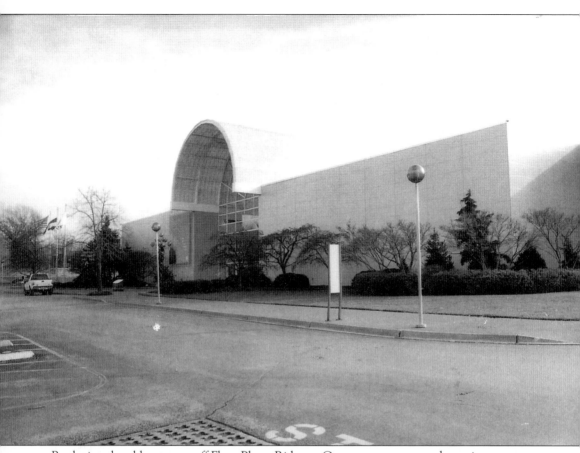

Replacing the old entrance off Flora Place, Ridgway Center now serves as the main entrance to the Missouri Botanical Garden. It is located at 4344 Shaw Boulevard and is fronted by a large parking lot to accommodate the hundreds of thousands of visitors that travel there every year.

Three
Tower Grove Park and Reservoir Park

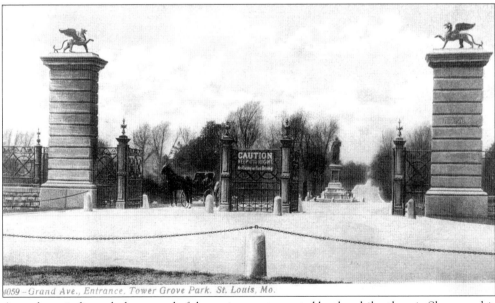

4059 – Grand Ave., Entrance, Tower Grove Park, St. Louis, Mo.

As we have indicated, the second of the major assets created by the philanthropic Shaw was his great park, the Tower Grove, which he had carefully cultivated over the years. Here, in formally designated patterns, (Gothic Revival) he laid out the walkways, the gazebos, the giant lily ponds, the statuary, the music stand, the attractive bridges, and the hundreds of species of trees that line the park. He conceived this tract as an English garden, like those that he had so admired in his visits to his native England. Picturesque it was indeed, with nonetheless a certain air of classical authority that strikes its many visitors even today. Here, in the photo above, we witness the grand manner in which his gateways and walks were laid out. This is the east carriage entrance at the turn of the century, with its two forty-foot Morris towers, as we enter from Grand Avenue. (© 2004 Missouri Botanical Garden.)

Here, we have one of the many statues of famous men that line the park. Standing above the pedestal is Christopher Columbus to remind the onlooker where it all began. The statue was erected in 1884. Henry Shaw commissioned these statues.

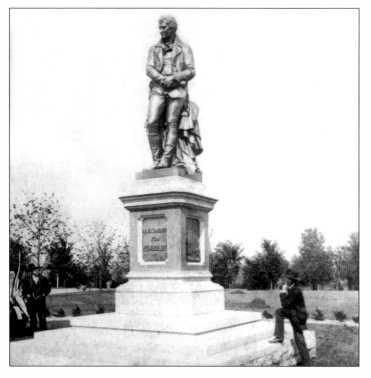

In keeping with the decorative design of the park, as we have reported, various statues were installed to celebrate the artistic and educational life. Here is one such presentation, a of a statue of the famous scientist, A. Humboldt, as his likeness was being admired by several onlookers. (© 2004 Missouri Botanical Garden.)

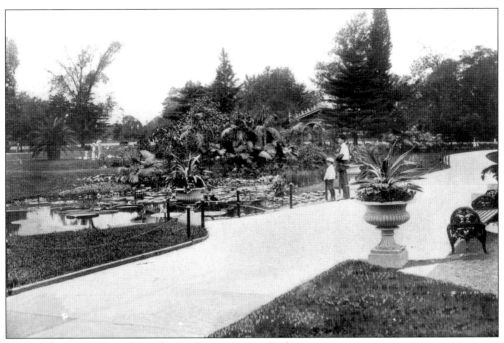

Man and son enjoying the sights in Tower Grove Park.

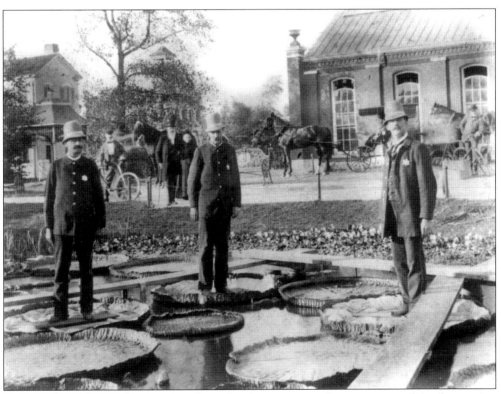

Here, we have three policemen posed on what became a popular experience of the day, testing the strength of certain giant lily pads in the park. (© 2004 Missouri Botanical Garden.)

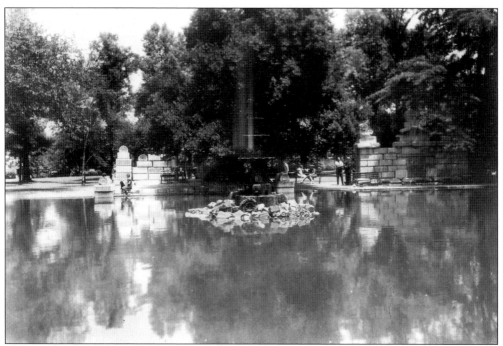

In order to capture the ambience of the classical ruins of Europe, Henry Shaw had his own "ruins" installed around the park's central pond. Shaw acquired these "ruins" from the remains of the Lindell Hotel, which was destroyed by fire in 1867. (NPS.)

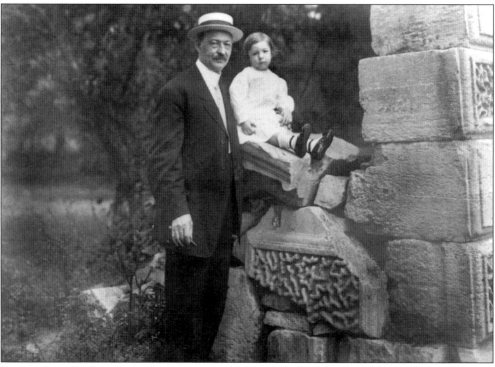

Here, a formally dressed gentleman poses with his son before the famed "ruins."

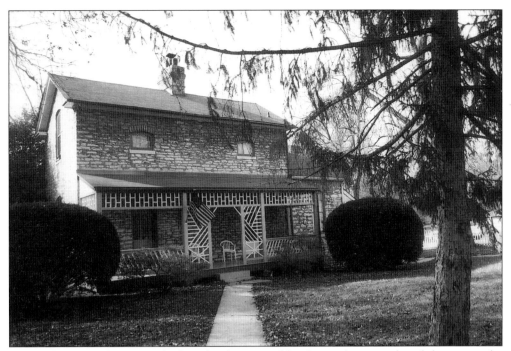

This 19th century house was built with adjacent stables. It is to be remembered that it was the horse and buggy that traversed the park's roads during that time.

And here is a photo of the park's 19th century stables themselves.

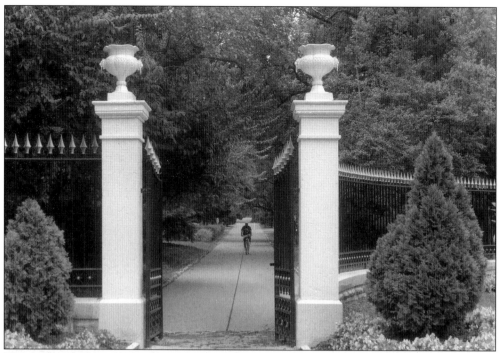

This north entrance displays the classical characteristics that so ennobles the grounds. Here, we see the pillars, urns, and spiked wrought iron fence that provide the structure with both authority and grace.

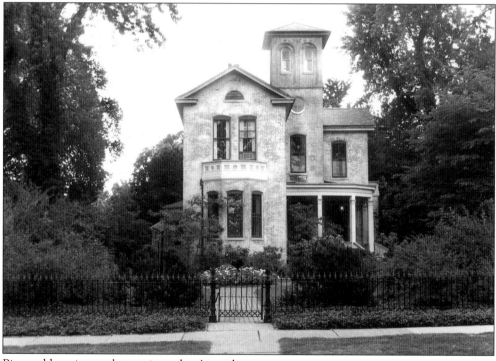

Pictured here is a park superintendant's residence.

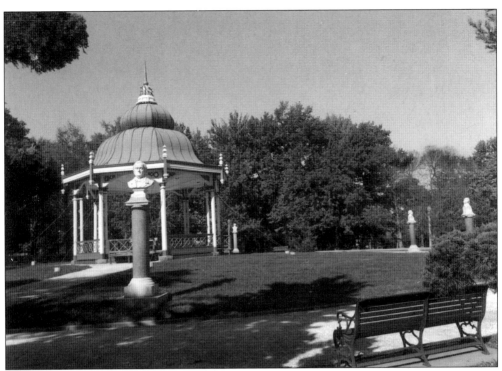

Pictured here the park's music stand, from which has come concerts for decades. It is surrounded by statues of notable composers.

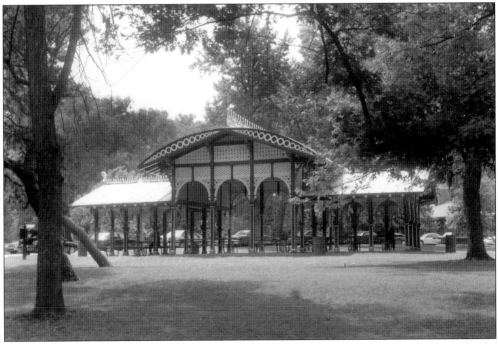

This is only one of the many pavilions that dot the park. It is generally used by the public for picnics or other functions. It is named the "Sons of Rest Pavilion," and dates from 1872.

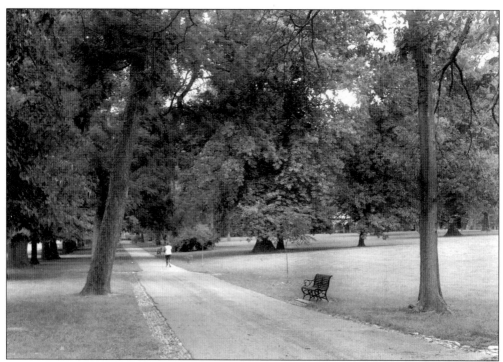

One of the central paths that run through the park with clean, open symmetry. These lanes are used extensively for exercising, promenading, or simply walking.

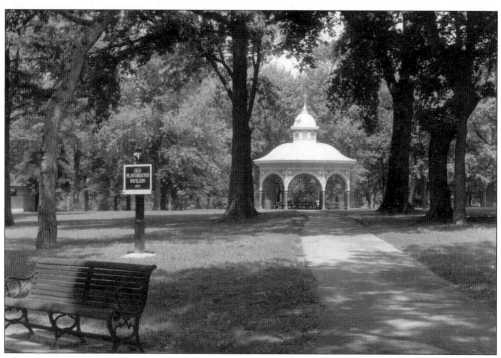

This gazebo-like structure is called "Old Playground Pavilion."

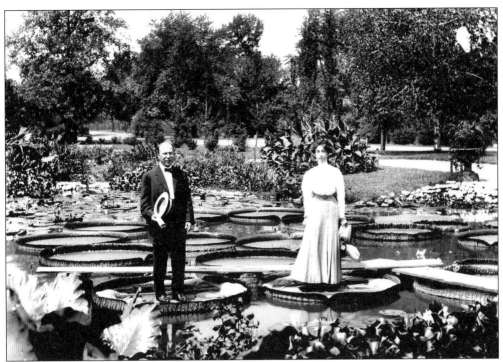

Early in the 20th century a man and woman continue the tradition of standing in a lily pond.(© 2004 Missouri Botanical Garden.)

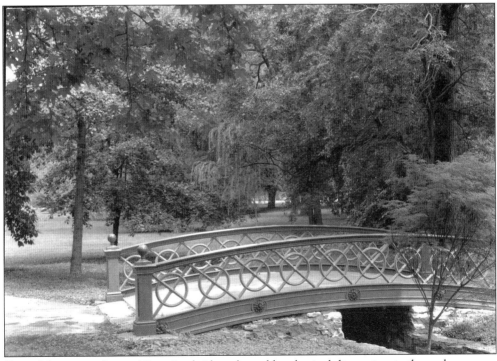

One of the many elegant Victorian bridges that add a classical dimension to the park.

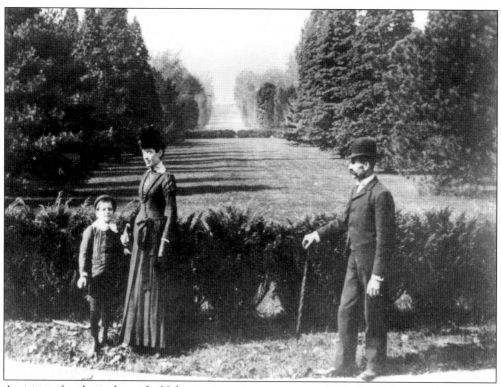

A visiting family in the early 20th century pauses momentarily for the camera as they pose in the park. Notice how formally they are dressed. (© 2004 Missouri Botanical Garden.)

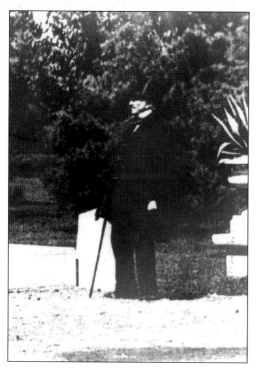

An 1880s photo of Henry Shaw in his beloved park. (© 2004 Missouri Botanical Garden.)

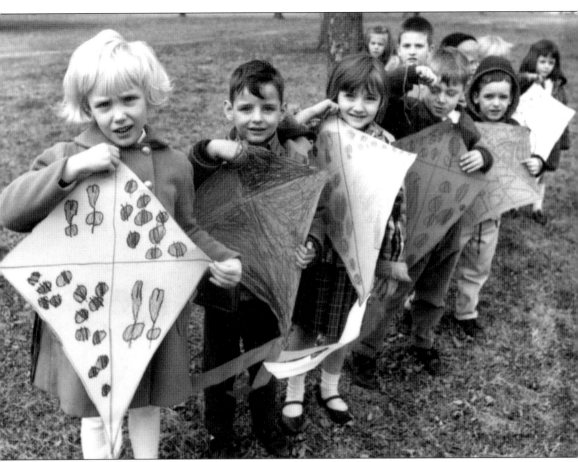

Here is an example of the park acting as a playground for youngsters from the nearby Sherman School. This kindergarten class of March 1967 is pictured here with kites they had made themselves.

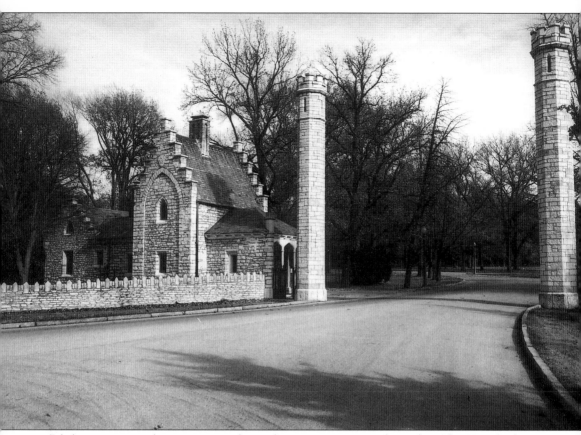

Of the monumental entrances to the park, none is more striking than the Kingshighway entrance. What provides it with its particular appeal is the stone house that stands next to it.

The second major park in our Garden District is the singular Compton Hill Reservoir Park, at Grand and Russell Avenues. It fronts a giant reservoir of water, which supplies reserves for the city's southern vector. With its monumental water tower, built in 1898, and landscaped gardens, the park is perhaps the only one of its kind in the United States. The tower itself is one of three in the city, and shares with the other two of being three of a limited number still standing in the United States which were made of brick to serve neighborhoods.

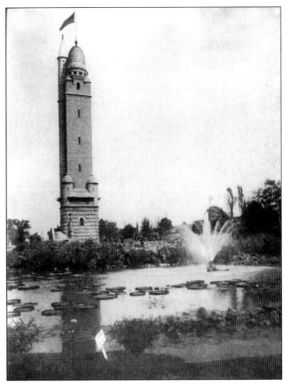

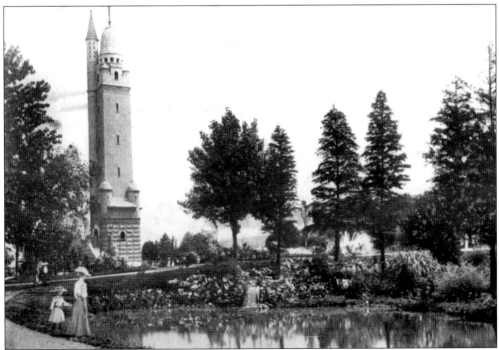

Although the park was landscaped at the turn of the century in the manner herein depicted, it lost much of its beauty in the years that followed through neglect and indifference. Now attempts are being made to not only revitalize the park but to remodel its 179-foot-high limestone tower.

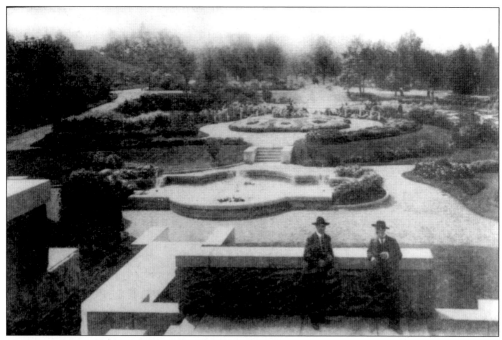

Here is another version of the early park at its best, as a parterre with artfully patterned walks, shrubs, and fountains.

In the center of these embellished walkways were round pools of gushing water. (c. 1914)

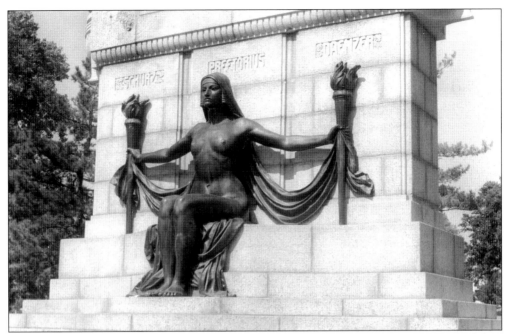

In order to honor three German-American journalists who had contributed much to the life of the city, the German citizens of St. Louis commissioned this stone plaque by the German artist Wilhelm Wanderschneider. Since it was declared by some that this unclothed "The Naked Truth," was too daring for St. Louis, the statue became a center of controversy in 1914. It was also a lightning rod for anti-German sentiment during the war years.

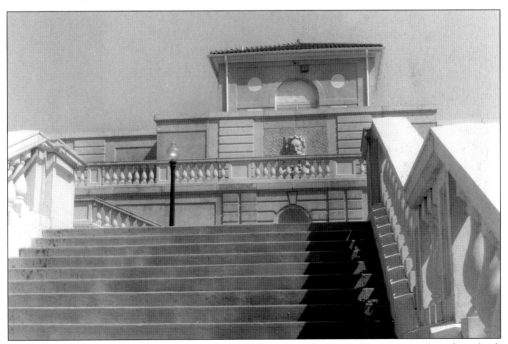

Here are steps leading up to the reservoir itself. With echoes of the Renaissance, this climb reminds us of the Spanish Steps in Rome.

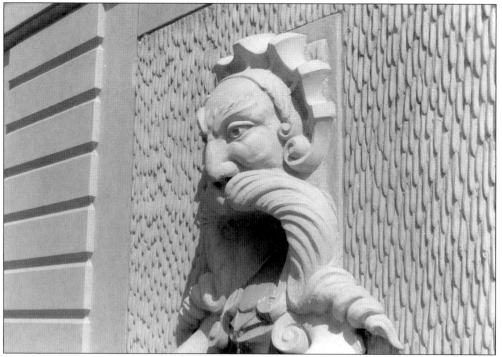

This gothic figure is the gargoyle that guards the entrance at the top of the reservoir's stairs.

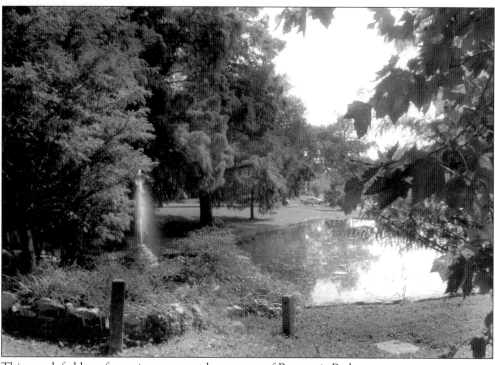

This pond, fed by a fountain, captures the essence of Reservoir Park.

Four
COMPTON HEIGHTS

A gaudy, overly decorated structure first marked the entrance to Compton Heights until the present marker, designed by well-known artist Rodney Winfield and Fred Hellebus, replaced it in 1966. Compton Heights had its beginnings as real estate for working-class families. As early as 1854, ads were published proclaiming its availability to "people with tiny capital." As part of the vast common fields (Pairie des Noyer), real estate entrepreneurs such as Mary Tyler and Henry Shaw were obtaining vast tracts of land from the original purchasers of these common grounds. It is to be remembered that growing St. Louis would be expanded to include the new subdivisions that Mary Tyler and Henry Shaw were planning. Construction of new homes in this area grew apace as various subdivisions were established by developers. One of these was Compton Heights, and later would become the home of a good number of successful German businessmen, who, as we have seen, built elaborate houses there to escape the crowded city. Most of the homes built there, designed by leading architects, still stand and are protected by associations that guard these grand reminders of the German past.

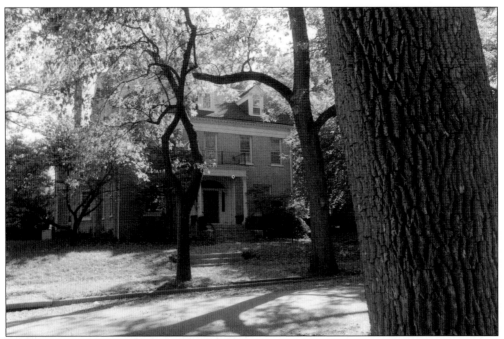

The present home of Mike and Emily Grady, at 3112 Hawthorne Boulevard, is of particular interest because of Olympian attempts to restore and recapture its original beauty. With its elegant foyer, library, parlor, butler pantry, and dozens of rooms, it amply echoes the handsome style with which the original owner, Gustave Riesmeyer lived.

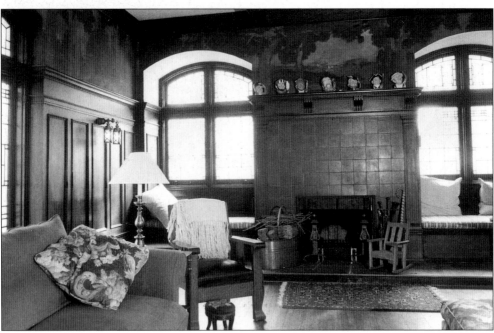

The most spectacular of the features at 3112 is this room with its arched wide windows, tiled fireplace, and paneled walls. The room was taken without change from the Bavarian Inn at the 1904 World's Fair.

This 1893 residence, at 3262 Hawthorne Boulevard, was built for W.A. Zukoski, owner of a highly successful millinery firm on Washington Avenue in downtown St. Louis.

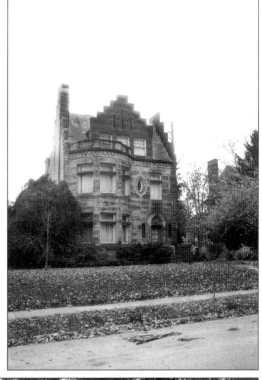

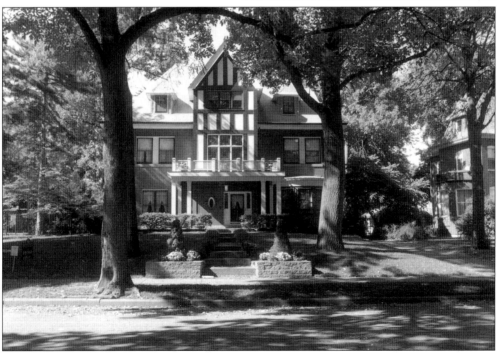

This home at 3013 Hawthorne Boulevard was designed by William Ittner, the famed architect, for Calvin M. Woodward, a former teacher at Washington University. Woodward was known for his pioneering of the teaching of the mechanical arts in the schools.

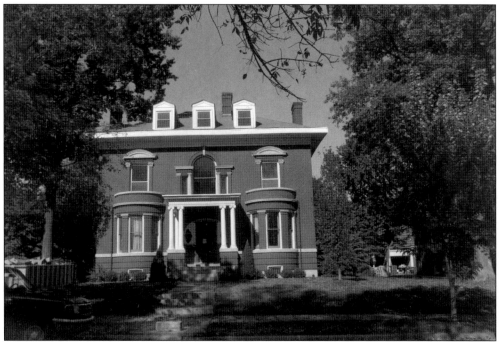

This house, at 3233 Hawthorne Boulevard, was originally built for Frederick Hoffmann, who headed a dried fruit and produce company in the city. Many of the prosperous German families that moved into the heights were successful professional or business citizens. Many belonged to the prestigious Liederkranz Club, and many intermarried with others that lived in the heights.

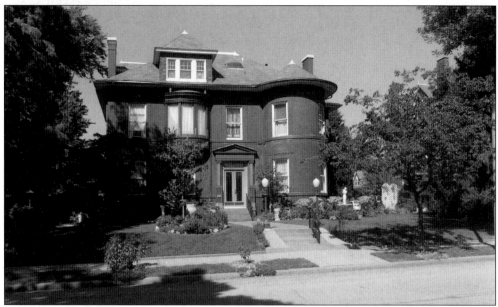

A group of noted German architects designed various homes on three principal streets—Hawthorne, Longfellow, and Russell. Here, at 3453 Hawthorne Boulevard, is a home built by Otto Wilhelmi for John Conrades, another prominent citizen. Wilhelmi is best known for his design for the water tower in Reservoir Square.

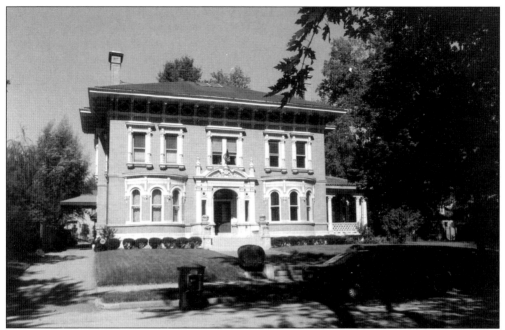

The home at 3419 Hawthorne Boulevard was designed by another noted architect, Ernst Janssen, for George Adolf Meyers, the president of a wholesale grocery firm. This grand structure was reputed to have sold for $45,000, a goodly sum in those days.

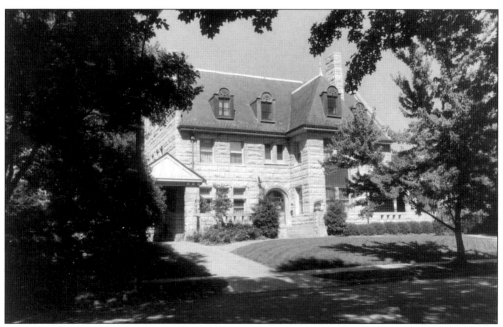

Theodore Link, who designed Union Station, was among the architects that designed this stately house at 3435 Hawthorne Boulevard, one of the finest in the enclave. It was built for Otto Bollman, who owned a music business in the city. To reflect Bollman's connection to his calling, a music motif is maintained throughout the house. There are, in addition to a music salon, various stained glasses with motif music notes etched upon them.

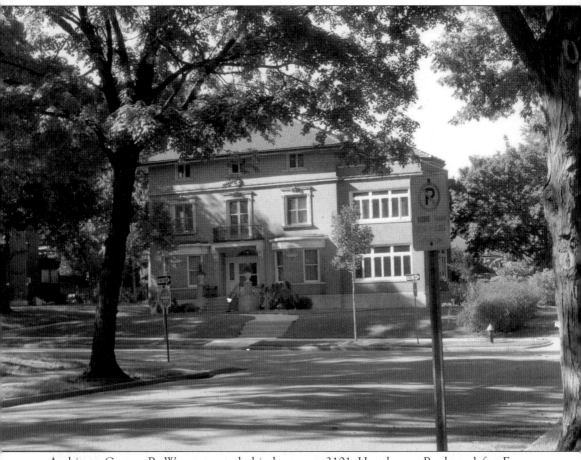

Architect Gustav P. Wuest created this house at 3101 Hawthorne Boulevard for Eugene Lungstras. It was built somewhat later in 1902, and is noted for its grey brick façade with a terra cotta trim, a trim that was very popular in the design of these Compton Heights houses.

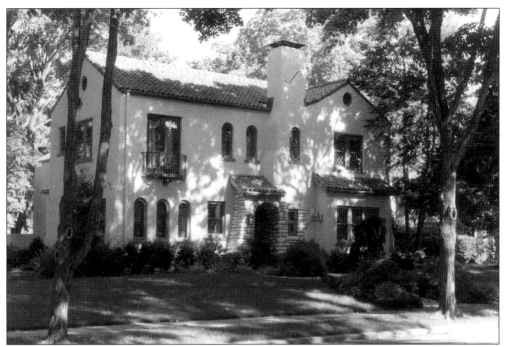

This home at 2959 Milton Boulevard, boasts an imposing tower. The home was built by the Charon Realty Company in 1926 for Frank Hiemenz, who later had alterations and additions made to the structure.

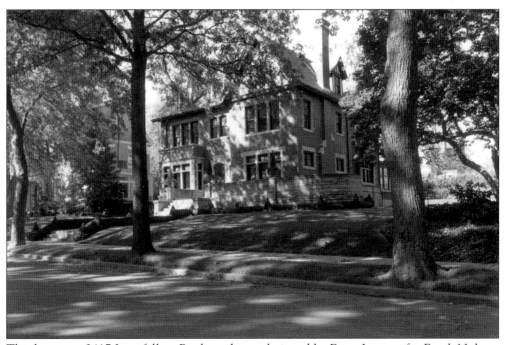

This home, at 3417 Longfellow Boulevard, was designed by Ernst Janssen for Frank Nulsen, of Missouri Malleable Iron Works. After his daring flight, Charles Lindbergh dined there on one occasion.

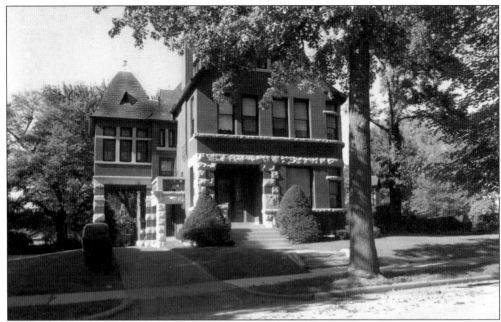

This house at 3533 Longfellow Boulevard was erected in 1890, its architect unknown. It was built for Z. Wainwright Tinker, a business man with many interests. Its very eclectic style uses stone and brick lavishly. Yet despite its attempts at ostentation, it never really comes off. The house, although built at a cost commensurate with the others in the neighborhood, remains rather humble and unimposing.

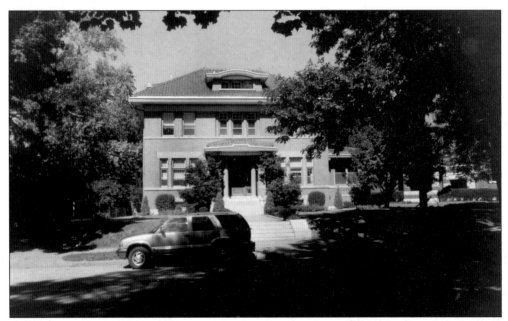

Architect Frederick Widmann designed this house, at 3545 Longfellow Boulevard, for himself. He embodied many of the Prairie School features in its construction. These may be detected in the wide over-hanging roofs, with one such roof built squarely over the front porch entrance. There is also a side cupola, which is new for its period.

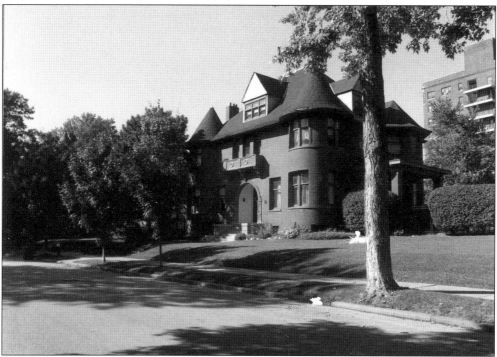

This Richardsonian Romanesque structure, at 3439 Longfellow Boulevard, was built by William Ittner for Charles Wulfing, the wholesale grocery magnate. With its two Queen Anne towers, cupola, arched entrance, and pitched roof, it unremarkably reflects the stock taste of the day.

Behind an old mansion on Hawthorne, an old carriage house now sits idle.

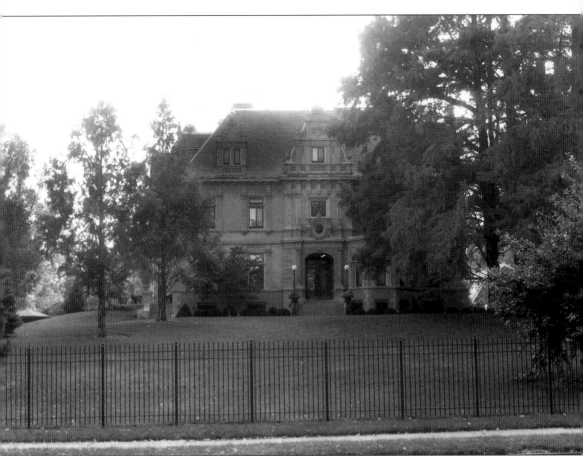

By any measure, the striking edifice at 3400 Russell Avenue far outclassed any other built in the area. This lavish structure was designed by Ernest Janssen for Charles A. Stockstrom in late 1927. One can readily see the French chateau influence in its exterior commingled with both Renaissance and Gothic effects.

Five
PRIVATE STREETS

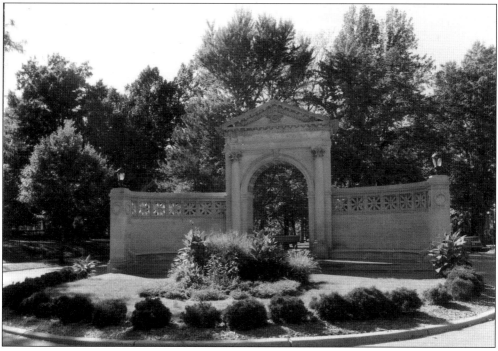

As Shaw went about establishing his famous garden and its nearby Tower Grove Park, he turned his attention, as we have indicated, to the real estate bordering them. In time, from the open fields, he and other developers created roads and homes to attract general buyers. Two such locations were Flora Avenue and Shaw Place. In the picture above we can see the impressive steps he took with Flora Avenue, which led directly to the entrance of his garden. This monumental and stately gateway to Floral Avenue, as it was then called, was created by his favorite architect, George I. Barnett.

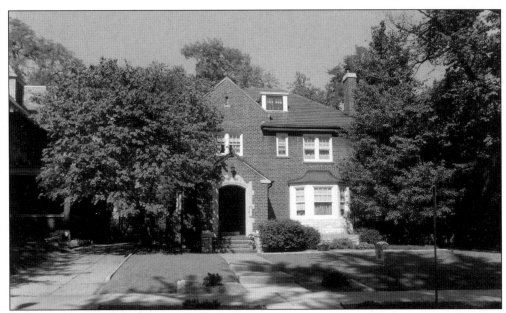

The street leading to his beloved garden was of particular interest to Shaw, for as early as his planting of hundreds of trees in the garden itself, he also arranged planting on Flora Place. Early illustrations of that day show only trees existing against a background of open fields and grass. In time, as we shall see, the avenue became one of elegant houses as that shown above, built by some of the first families of the city.

The avenue itself is laid out with a median between two separate thoroughfares. Although various streets intersect Flora Place at several corners, the avenue remains a quiet sanctuary of sorts, dignified by its carefully cultivated center of flowers and shrubs.

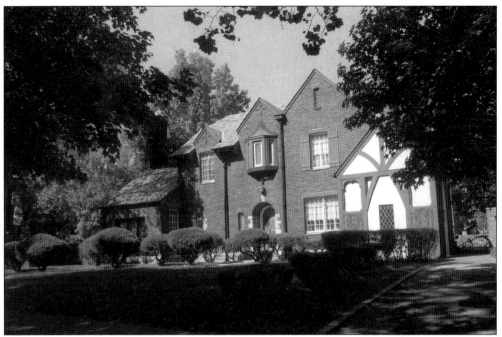

Many of the homes built on Flora have eclectic architectural styling. Here, this Georgian structure has echoes of French and Romanesque devices.

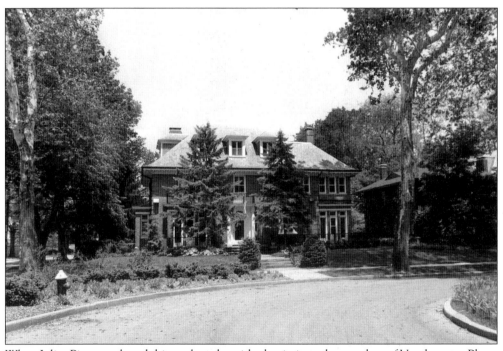

When Julius Pitzman platted this enclave, he wished to imitate the grandeur of Vandeventer Place, yet he wanted to avoid its linear roads. He therefore planned Flora Avenue with curvilinear roads to provide the area with a sense of quiet. Here is such a curve in the Flora road. Behind it stands one of the fine residences of the area. This house is near an old gate to Shaw's Garden.

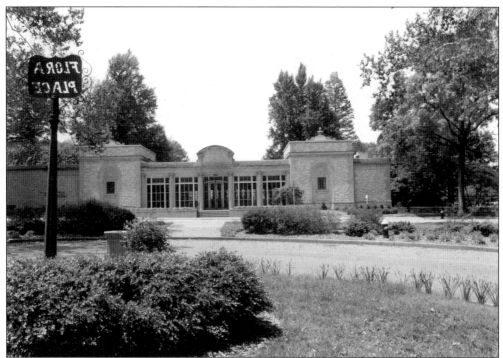

The old gate to the garden which had replaced the original gate in the 1920s remains as a symbol of the Garden District as a whole.

Another enclave set aside by Shaw was a small plot of land near Grand Avenue. Here, Shaw's architect George Barnett planned a tiny private place with ten red-brick houses. These humble houses were to be rented out, with the income going to the garden itself. In the picture above we see the sign marking the entrance to the community, which exists almost untouched today.

This house near the entrance, with the address of #9, was willed by Henry Shaw to his housekeeper.

This same house contains window-spaces that are closed by bricks. In this manner, the house's owner could avoid higher taxes, since taxes of that day were sometimes rated according to the number of windows the house contained.

In this photo we can sense the mood of quiet and serenity that still abides in this tiny community.

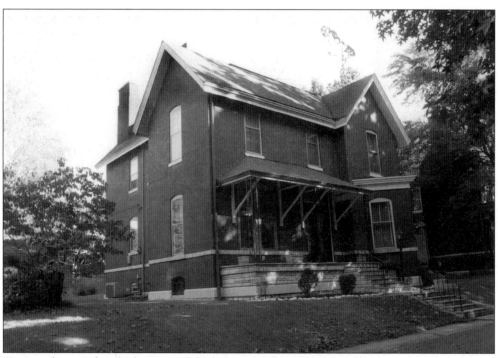

Here, we have a close look at one of the houses on Shaw Place. With its stone porch and many windows, this modest house still maintains a charm of its own.

This photo looks to the south gate of Shaw Place. These houses were individually owned after the garden sold the property in 1915 for $55,000.

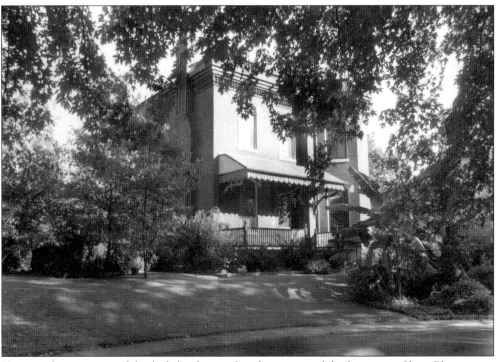

Here, we have a view of the lush landscape that fronts one of the homes on Shaw Place.

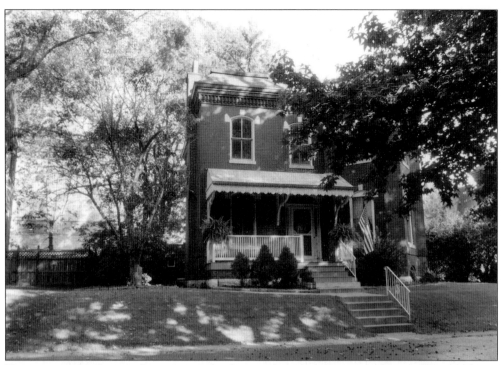

Here is an angle of vision that captures the distance between the ten residences. We would now think of this space as considerable.

When the grand Vandeventer Place was demolished, this copy of a pedestal fountain with a swan at its top was provided for Shaw Place's central walk.

Six
STREETS AND PROMINENT BUILDINGS

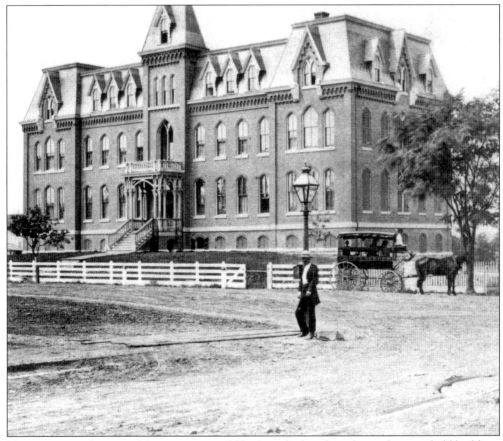

To garner a good vision of the past, one could look no further than this at this grand old building, Episcopal Orphan's Home. With its over-decorated exterior, we can see some of the funny flaws of the Victorian period. It has long ago been demolished, but once existed at Grand and Lafayette Avenues in the mid-19th century. (© 2004 Missouri Botanical Garden.)

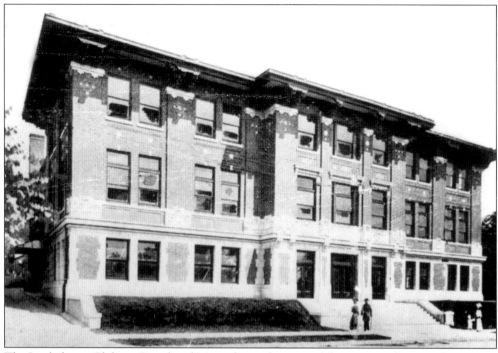

The Liederkranz Club, at Grand and Magnolia in this turn of the century photograph, was one of the most exclusive clubs in the city. Its membership was made up of mostly rich German professional men.

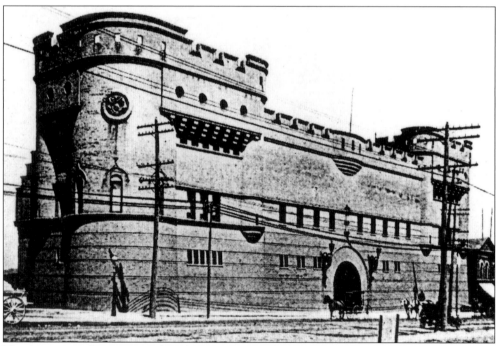

This bastion, with its grim medieval exterior, was called "Battery A" by the military. It stood at Grand Avenue and Rutger Street during the early days of the 20th century. (c. 1912.)

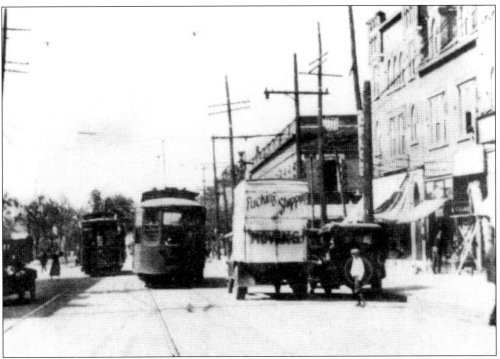

With the coming of the streetcar, passengers could have ready excess to areas once difficult to reach in the Garden District. Here is a photo of the traffic on Grand Avenue near Hartford Street with streetcars very much in evidence. As we will see later, when the busy Thirty-ninth Street lost its streetcars, it underwent a great decline.

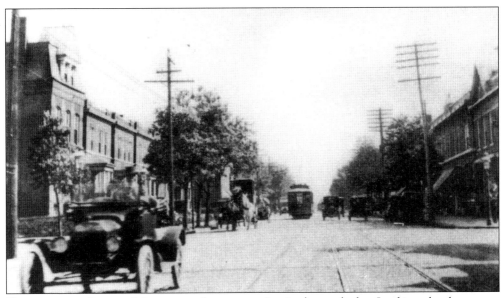

Here, we get a glimpse of the means of transportation in that early day. Looking closely, we can see a horse and buggy, the new streetcar, and the newer automobile as they once existed near Grand Avenue and Arsenal Street.

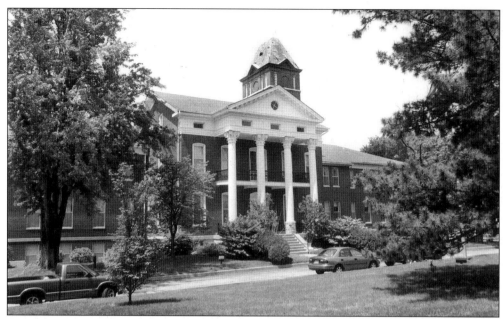

This beautiful old home was turned into an elegant retirement home for seniors. This classical structure, at 3625 Magnolia Avenue, was originally erected for the silversmith Rene Beauvais. Later, it became a home for the elderly and for veterans of the Civil War. Now, elaborately innovated, it is again a retirement home.

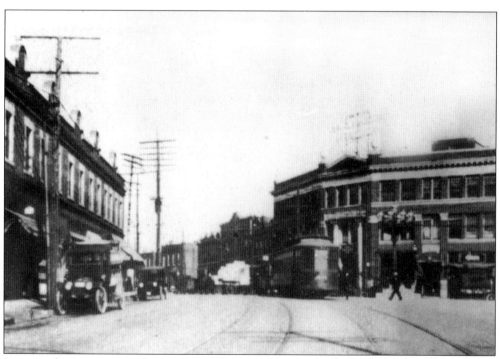

It was at this intersection that commercial shops and stores had a start in the Garden District. Business grew apace on Grand Avenue until it became what it was at its zenith—one of the busiest streets in the city during the early 20th century.

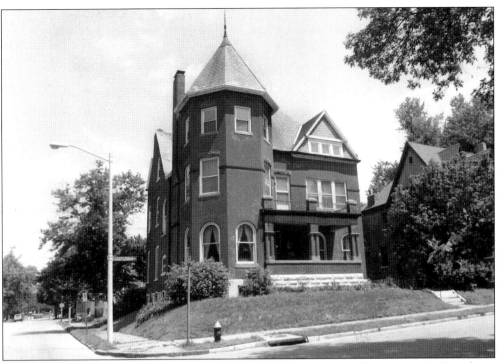

This is a house on Castleman Avenue, with a Queen Anne tower, pediments, arched windows, and pitched roofs –all characteristics of the popular architectural style of the times.

This residence, owned by Kathy Kuba, at the 3800 block of Castleman Avenue, was built in 1895 and is one of the oldest on the block.

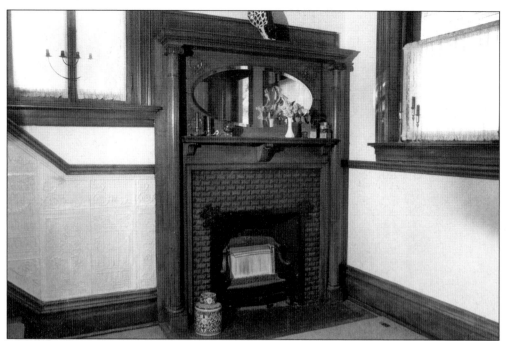

An unusual feature of the Kuba fireplace is that part of its exterior is made of pressed leather. This fireplace and mantel are carefully maintained as a happy retention of the past at this address.

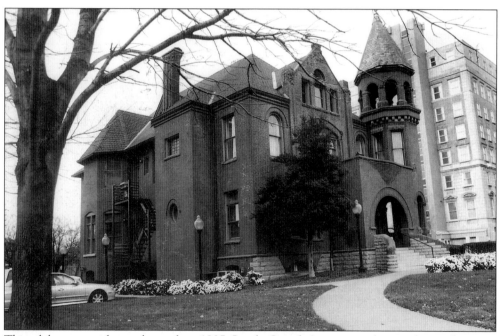

This elaborate residence, located at 1905 South Grand Avenue, with its echoes of various architectural styles, particularly the Romanesque, is now the Mental Health Association of Greater St. Louis. Once the Warner Mansion, it was built by Theodore Link for E.H. Warner, and is noted for its hardwood furnishings. It is also a reminder that Grand Avenue once flourished as a resident street full of houses of this nature.

At one time, the eight-story Saum hotel, built by the Saum brothers, was one of most fashionable in the district. Located directly across from the Compton Hill Water Tower and Reservoir, it attracted an affluent clientele with its shops, suites, and eighteen pent houses.

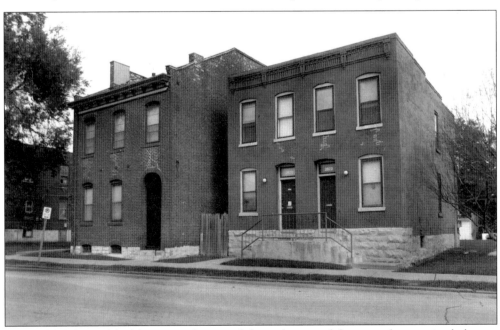

These old-fashioned buildings reveal some of the architectural features of many simple homes in the area. These two differ somewhat, one has a pitched roof, the other is flat, and one seems to be a single residence, the other a duplex. The house on the left is the older home, of course.

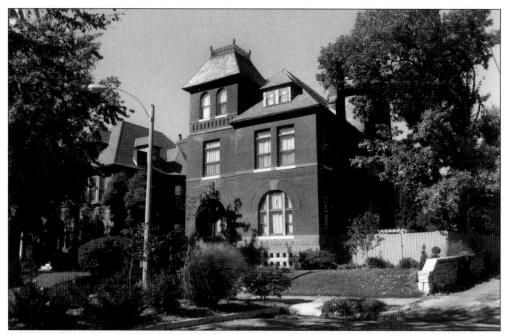

In contrast to the humble houses shown above, the next two houses illustrate some of the more costly and more gracious houses in the district. This house, on Flad Avenue, has Richardson features of rounded windows and heavy arches in the middle-class mode of the day. Moreover, its yard is more spacious in contrast to the small front yards of the poorer dwellings of the times.

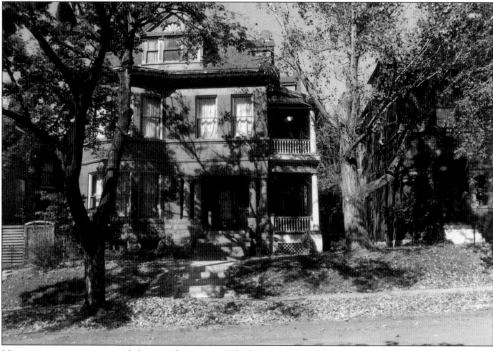

Here is an even more elaborate home on Flad Avenue, with its twin veranda porches and two cupolas.

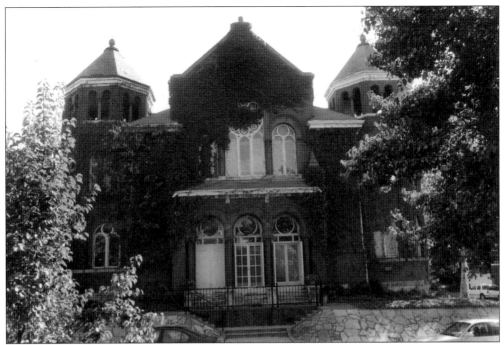

The Temple Apartments, at 3666 Flad Avenue, has had a chameleonic career. It started out as a Jewish temple, became the Compton Heights Christian Church, and for some time acted as the parish school of St. Margaret of Scotland Catholic Church. In 1982, it was converted into a series of apartments.

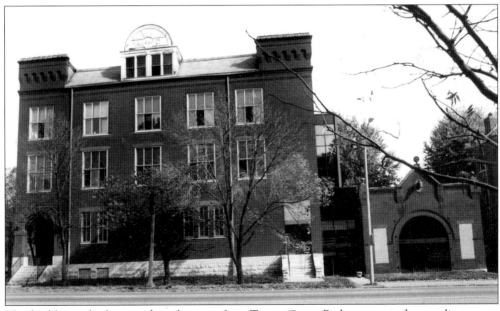

This building, which exists directly across from Tower Grove Park, once acted as a police center for the area. However, it was later occupied by the famous Emil Frei Stain Glass company after the police station was closed. Notice the once busy horse stable.

On Shaw Avenue, near the garden, one comes upon an array of garden statues and pedestals that are placed mostly on the sidewalk of this store. One is reminded of the statues of all descriptions that a buyer could purchase in similar displays in Florence and other Italian towns.

As we have indicated, once a thriving center of commerce, with bustling crowds of shoppers, Thirty-ninth Street suffered a decline once its streetcar lines were removed. Happily, it is in the process of recovery under the direction of the Thirty-ninth Street Redevelopment Corporation.

Seven

CHURCHES

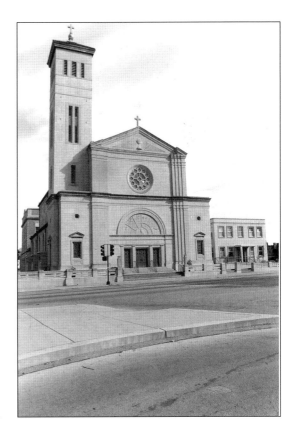

Pope Pius V Roman Catholic Church, a
fine structure located at 3310 South
Grand Avenue, was constructed to
imitate the Roman church, Il Jesu. Built
with Carthage stone marble and barrel-
vaulted ceilings, this church is one of
the most outstanding in the garden area.

St. Margaret of Scotland Catholic Church, at 3854 Flad Avenue, was built in 1907 when it moved from its original store-front home on Thirty-ninth Street. In its heyday it contained 10,000 members, but declined with the general trek to the suburbs. Today, however, it is the most progressive church in the Garden District in its attempt to revitalize the area around Tower Grove Park.

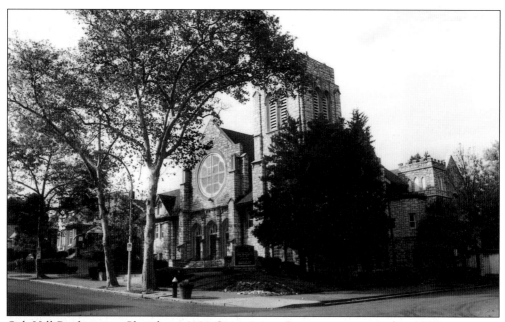

Oak Hill Presbyterian Church, at 4111 Connecticut Street, was organized in 1895, in an area so uncultivated that its parishioners had to stomp through muddy fields to attend its services. They often stood at prayer in muddy boots.

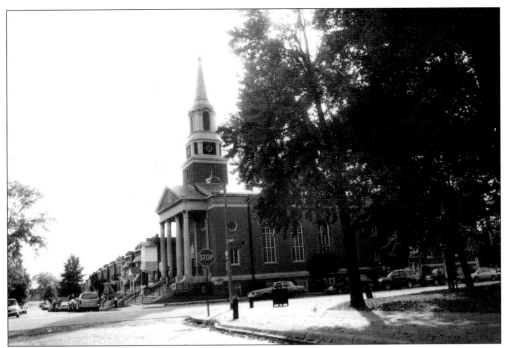

Scruggs Memorial United Methodist Church, at 3443 Grace Avenue, was built with classical Federal lines. It was named after the department store magnate Richard M. Scruggs, who contributed heavily to its construction.

Church of the Holy Family, located at 4125 Humphrey Street, was founded in 1898 as a German language house of worship. It grew until its parish erected this present church. Built in a Romanesque manner, of a sturdy granite, it has endured many changes and transitions, adding schools and parish centers throughout the years.

The Shaw Avenue United Methodist Church is located at 4265 Shaw Avenue.

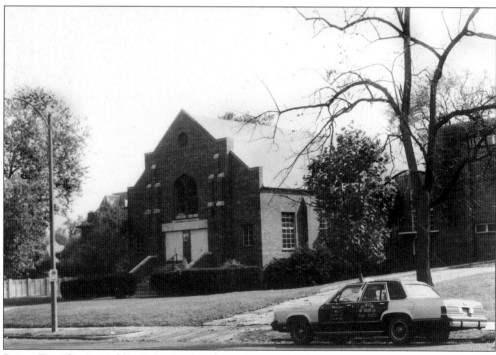

Berea Temple Assembly of God Church and its parish is located at Compton and Russell Avenues in the Garden District. The building itself is noted for its unusual pitched roof with various windows placed in the façade that fronts it.

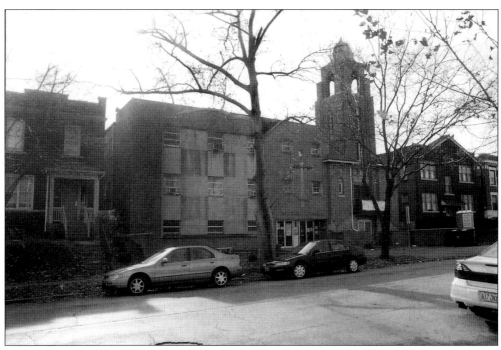

Mount Olive Lutheran Church is also located in the district, at 4246 Shaw Avenue. One of its most attractive features is a narrow tower with a half-dome at top.

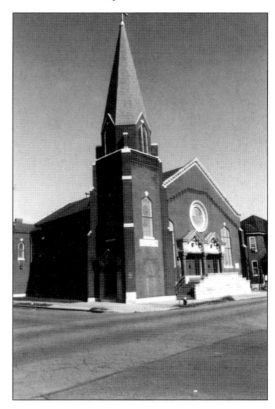

The Lutheran Church of Our Redeemer is another place of worship located in the garden. With its rose window and tower, and its embellished entrance it fits solidly in the Gothic tradition. It is located at Utah Street and Oregon Avenue.

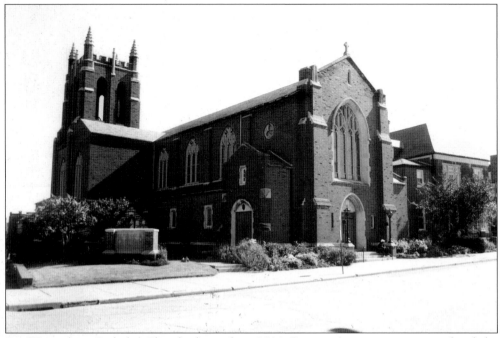

St. Wenceslaus Catholic Church, located at 3014 Oregon Avenue, retains much of the medieval pattern of church architecture. However, its tower and rose window are more elaborately designed.

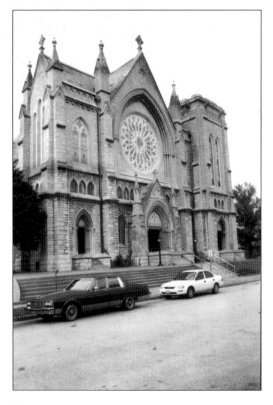

Perhaps the most elaborate of the churches built in the Garden District, Immaculate Conception, at Lafayette Avenue and Longfellow Boulevard, is indeed a prize architectural edifice. It was hailed at its opening as the best of its kind in the entire Midwest. With attractive wainscoting on its walls and an exterior of towers, three rose windows, and a rectory made of stone, it is admirably and spaciously built.

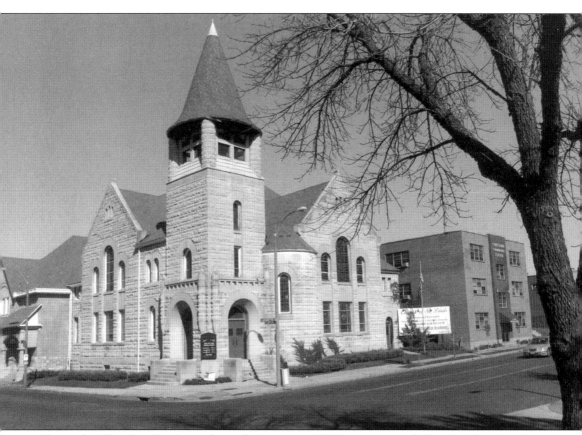

This is the Church of St. Louis, formerly Compton Hill Congregational Church. Theodore C. Link, the prominent architect, designed the original plan for the church, but it was rejected. The second architect was Warren H. Hayes, who created for this parish the current church, with its heavy Romanesque design. It is located at 1640 South Compton in the garden area, where it was originally laid out in 1894 in the then fashionable Compton Heights.

Compton Heights Christian Church, at 2149 South Grand Avenue, boasts a slender pointed steeple that overlooks the entire neighborhood.

This simple and small unpretentious church now stands in the shadow of other more dignified and portentous structures. The Body of Christ Temple is located at 3325 Arsenal Street.

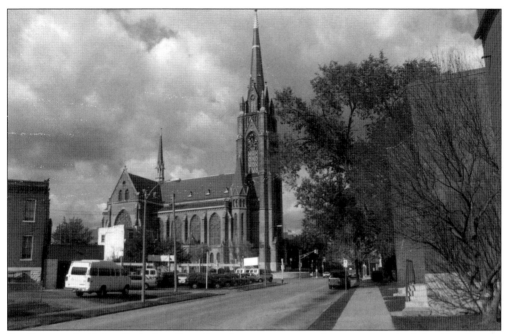

St. Frances de Sales Catholic Church is by any measure the great jewel of the South side. Eloquent and dignified as a cathedral, the church imitated many features of churches in Berlin and Frankfurt am Main. It was designed by a German architect called Seibertaz. It overlooks busy Gravois Avenue.

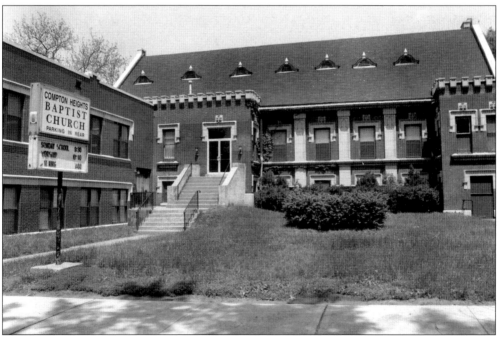

Compton Heights Baptist Church, with its varied ornate exterior features of many windows and cupolas, at first glance appears to be overdone. However, we find after further inspection that it wears well in its own way. Built in 1915, it is located at 3641 Russell Avenue.

Tower Grove Baptist Church is another example of the Federal American Colonial style, a church style that became prevalent as the century grew older. Notice the tall classical columns and the square, rather than arched, windows. It is located at Magnolia and Tower Grove Avenues.

This addition to Tower Grove Baptist Church retains many of the colonial features of the church—its columns and square windows. It provides education for its members.

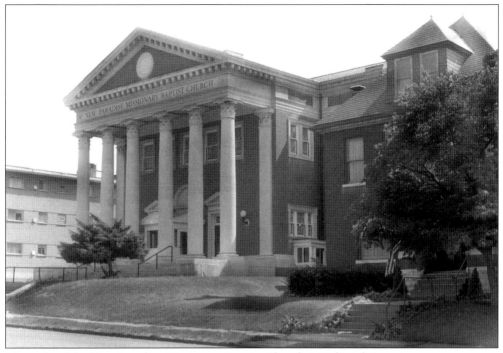

The style of the New Paradise Missionary Baptist Church is Colonial American, as we can see. The church is located at 3524 Russell Avenue.

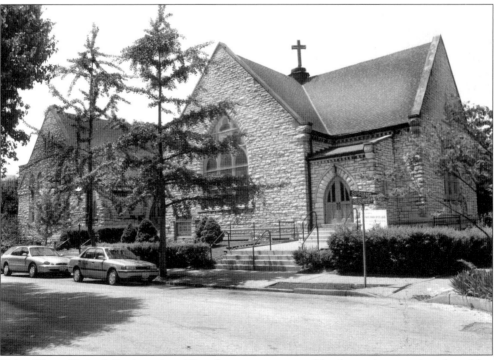

Tyler Place United Presbyterian Church, as we can readily determine, retains the older, traditional Gothic style. It is located at 2109 South Spring Avenue in the Garden District.

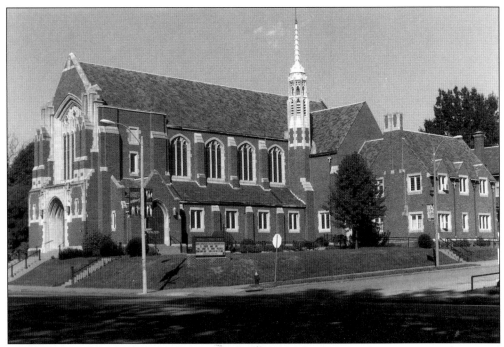

Messiah Lutheran Church, at Grand Avenue and Pestalozzi Street, has its own architectural blending of Gothic with other styles. The church was built in 1928.

Holy Innocents Catholic Church is located on Kingshighway Boulevard, directly across from Tower Grove Park. It is distinguished by a slender weather vane and by its majestic tall windows.

Eight
SCHOOLS

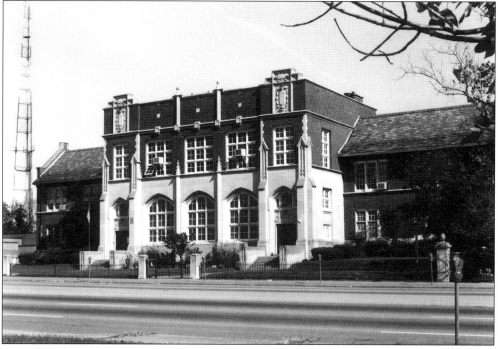

Named for the celebrated Gallaudet sons and father who did so much to advance the education of the deaf, this Garden District school was opened in 1924. It adapted all the methods of sign language, lip reading, and other means of communication that the Gallaudet sons introduced to the American public.

This is a class of students in June 1930, posing for a school photograph.

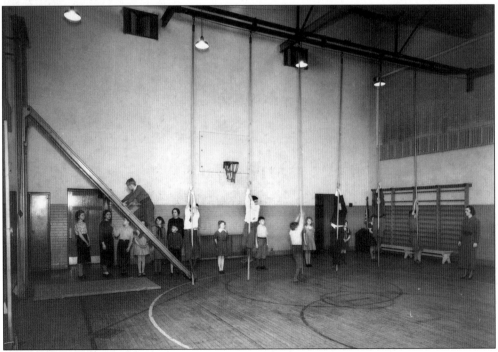

We see here a physical training class at the school in December 1935. Students are exercising with an arrangement of poles.

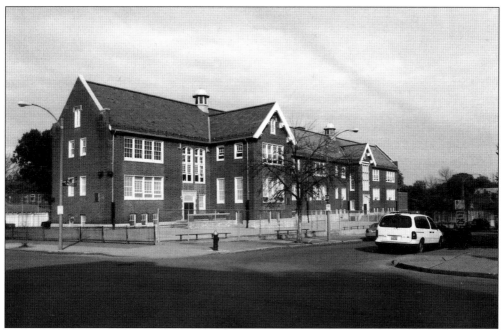

Horace Mann School, named for the noted educator, was designed by the famous William B. Ittner in a Tudor Revival style. This institution, located at 4047 Juniata Street, has been placed on the National Register of Historic Places, because of its significant architectural features.

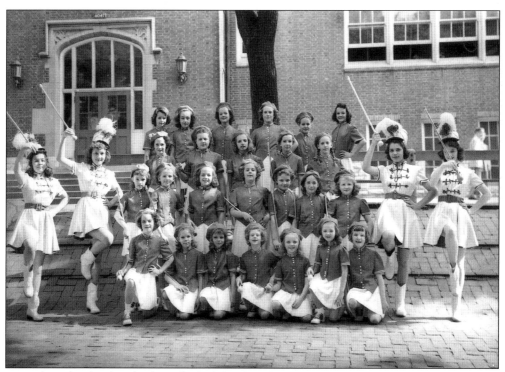

Here the school's cheerleaders, flanked by their baton parade twirlers, pose for their group picture in May 1952.

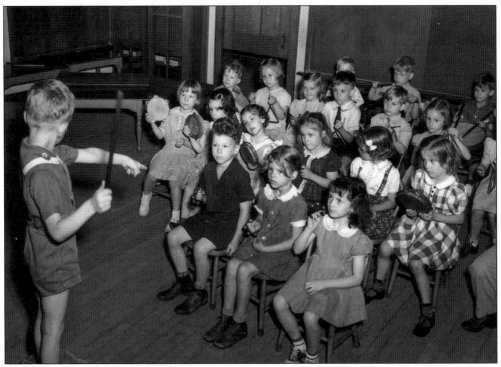

This is a photo of the May 1942 kindergarten rhythm band.

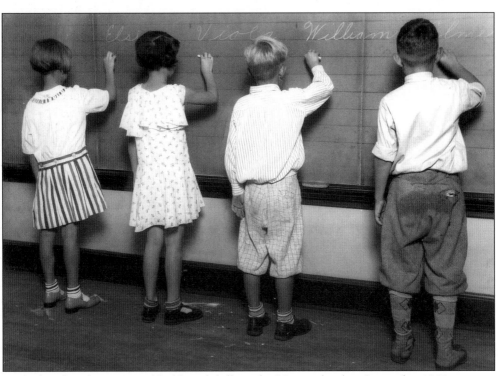

Second graders demonstrate blackboard skills at the Mann school in September 1930.

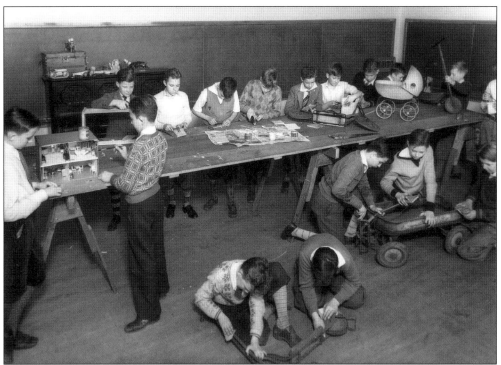

During the Christmas season of 1931, Horace Mann students are earnestly engaged in repairing broken toys for the poor.

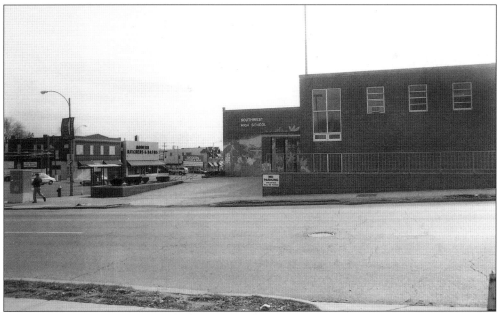

This section of Southwest High School was added to the original structure at Kingshighway Boulevard and Arsenal Street. Its rather bleak style compares unfavorably to the schools built in the area earlier by William Ittner and his team of architects. There are several Ittner-designed buildings in the schools we are picturing.

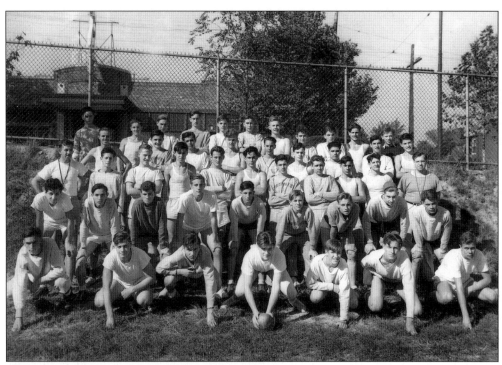

Here, posing for a group photograph is the mighty football team of Southwest in August 1938.

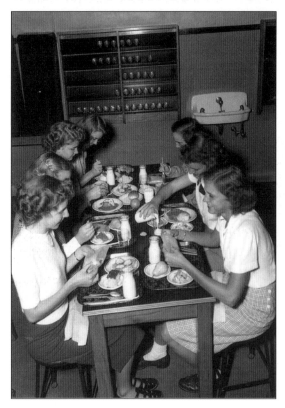

Young ladies at Southwest High munch away at their lunch in this school cafeteria photo taken in September 1947. There seems to be a stock lunch for all, with milk included.

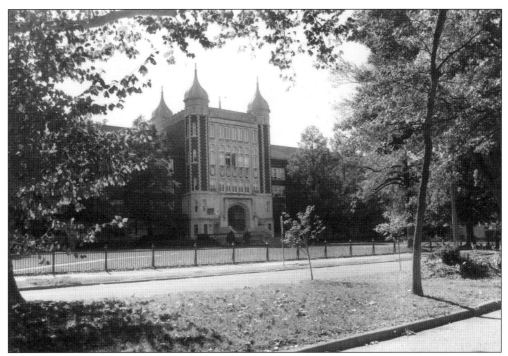

Roosevelt High School, once a desirable high school in the area, was named after the celebrated "Rough Rider." It is a building of monumental authority and beauty. Located at Gravois Avenue and Wyoming Street, it was built over grounds that once held a cemetery.

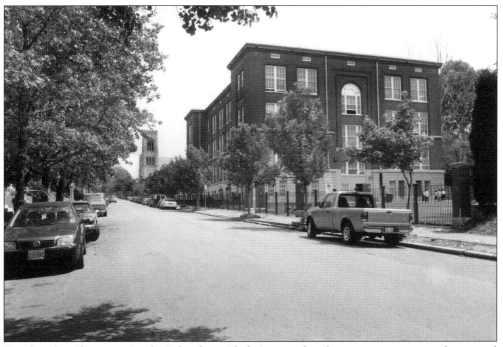

For decades Sherman Grade School on Flad Avenue has been an important educational forum in the Garden District.

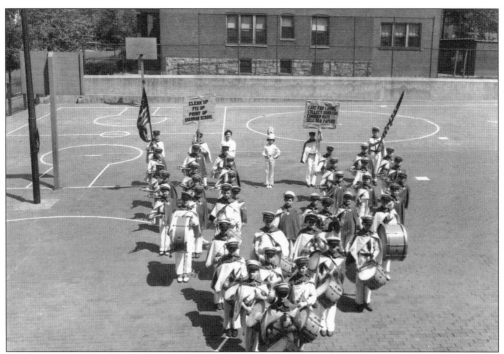

Here, the young students in the Sherman School drum and bugle corps have gathered in the school playground for a group photograph. (May 1942)

Pictured are the young athletes who make up the school's baseball team in May 1946.

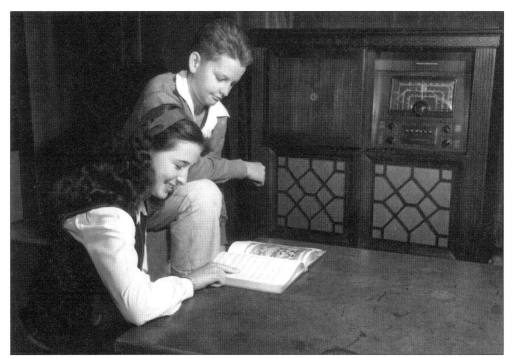

In September 1945, these students gather to study or to listen to the radio in what appears to be a student center. For that generation the radio was the main source of their entertainment, beside the movies of course.

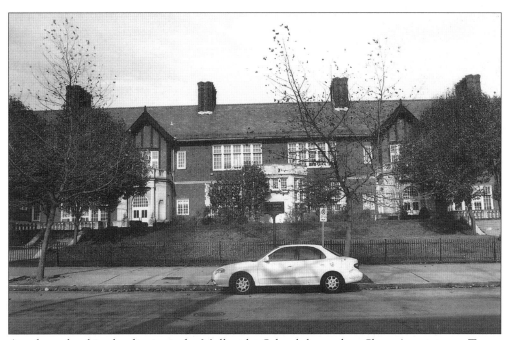

Another school in the district is the Mullanphy School, located on Shaw Avenue near Tower Grove Avenue. It is one of the almost 50 excellent school buildings designed by William Ittner and his team.

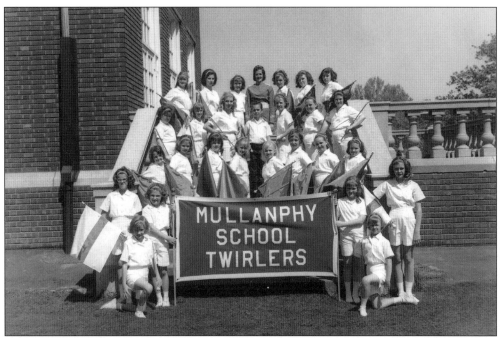

Here is a group photo of the school's active girls organization on campus—the Mullanphy Twirlers. The school was named after a member of the generous Mullanphy family that did so much for early St. Louis.

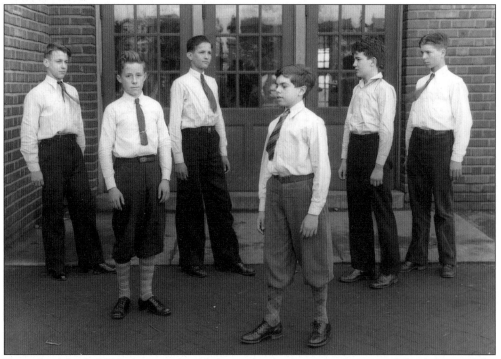

From this March 1933 photograph of lads at school we can catch some of the fashion of the times. Knickers and long pants for young boys seem to be the order of the day.

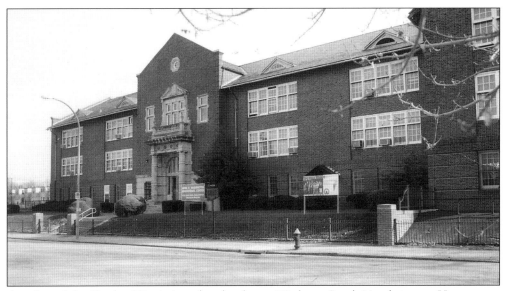

Another of the Garden District's early schools was Wade on South Vandeventer. Here we see the dwelling that it had moved to from a still earlier building. Again, we witness an architectural motif that has become prevalent among later schools. A central facade has been erected with a pediment finish, upon which has been placed a clock and the many square windows placed in a row of four. The only old-fashioned element is the decorative front entrance with its elaborate columns. It is now the Meda P. Washington Educational Center.

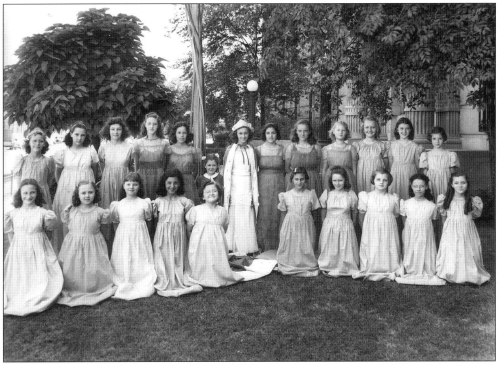

In imitation of the celebrated Veiled Prophet court, students have created their own court, with a queen to rule them all. This photo was taken in June 1939.

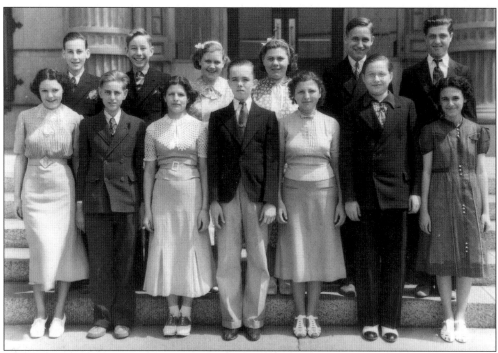

This is the class of June 1937—no knickers here.

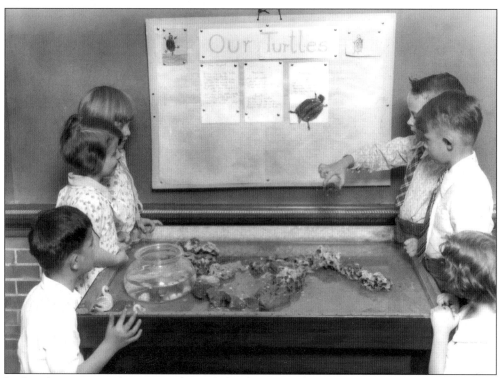

In this photo we can observe members of a kindergarten class in what was called a nature study. (November 1930.)

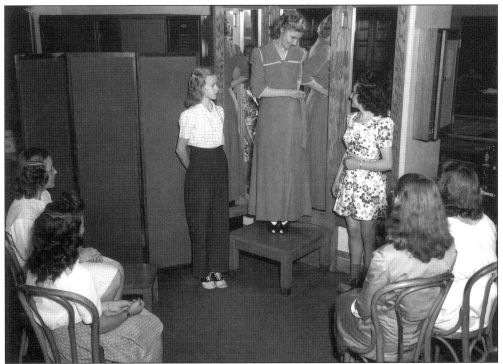

To demonstrate how modern the school was, Wade included in its schedule a class for modeling. Here, in June 1945, young ladies engage in striking the right positions for their audience.

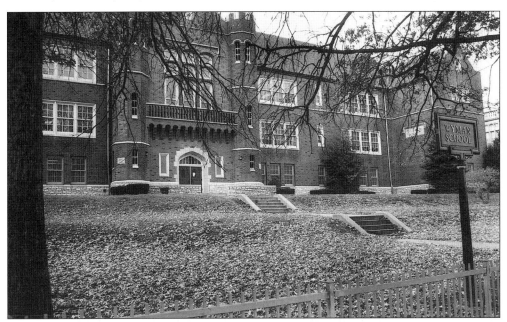

Another district treasure is the Wyman School, located at 1547 South Theresa Avenue and created in its elegant fashion by the ever-creative William Ittner. Here, we see some of the characteristics of his ambitious style, the ornate front with medieval and Renaissance echoes. The school is on the National Register.

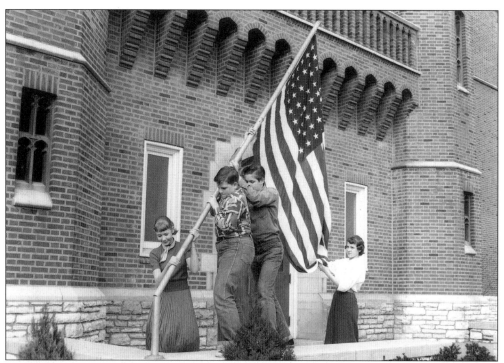

In this February 1955 photo we watch Wyman youngsters struggling to put up the stars and stripes.

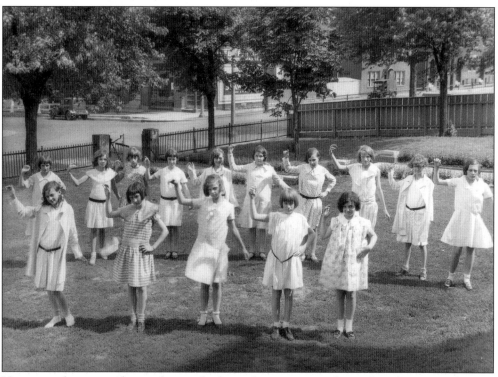

Here are girls wearing dresses they made themselves in a manual arts class. (May 1930.)

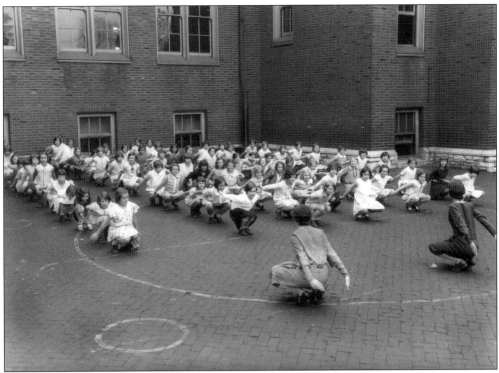

In this April 1931 photograph we witness a health and physical development class.

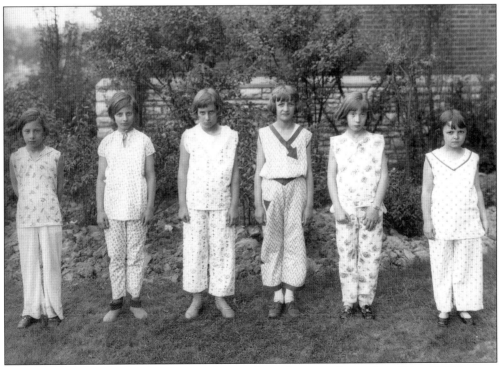

Here, young ladies display the pajamas they made in the manual arts class. (May 1930.)

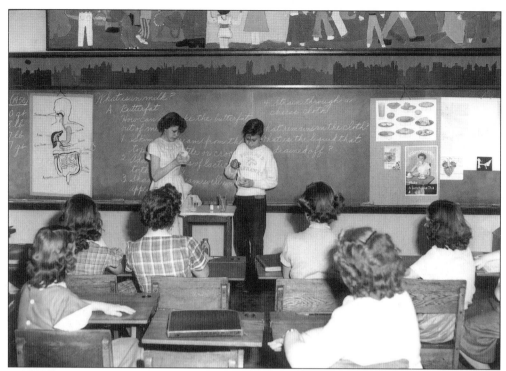

As we have shown, practical arts were emphasized at this school. Here, at this building, students are making butter. (March 1953.)

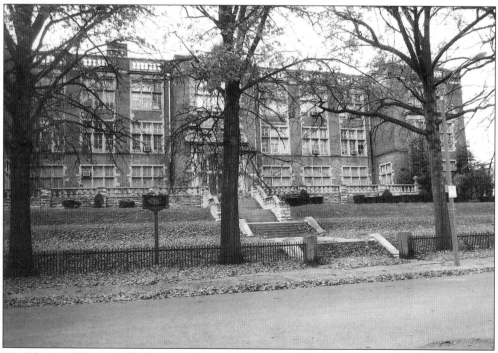

Neighboring Theresa School, is another Ittner creation. Housing is a probable future use.

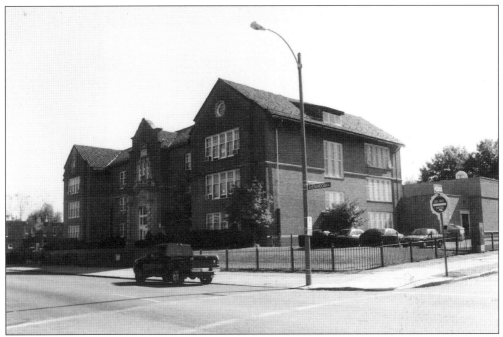

In our listing of Garden District schools, we must not forget Shenandoah, with its central façade and two projecting sides. Located at 3412 Shenandoah Avenue, this building was designed by R.M. Mulligan, who also did the Gallaudet School for the deaf.

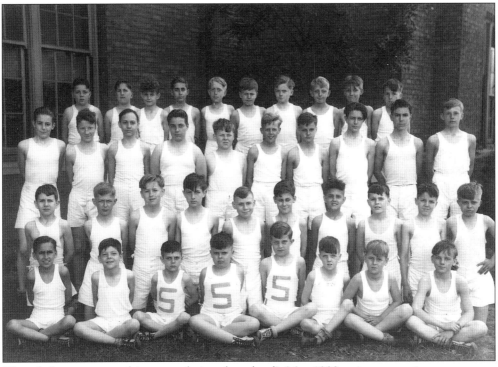

These lads were engaged in stunts during the school's May 1932 spring entertainment.

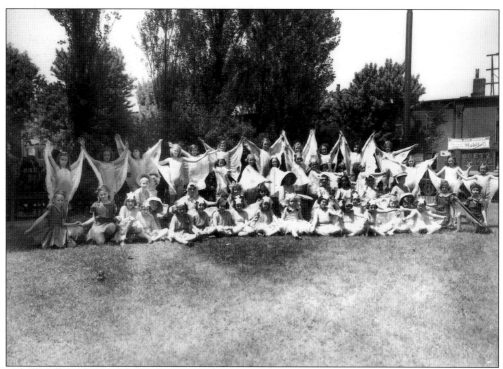

Students are costumed as butterflies in a dance sequence at the school's June 1937 entertainment.

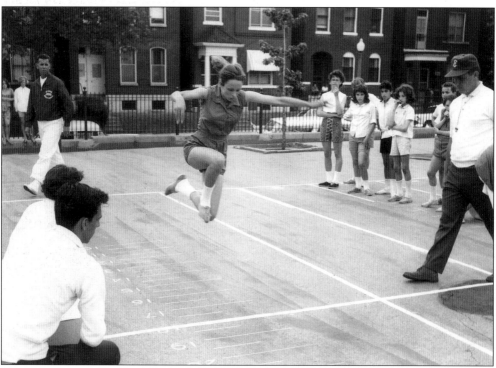

This young woman is competing in a May 1963 athletic meet.

In a January 1946 work class, students busy themselves in painting furniture.

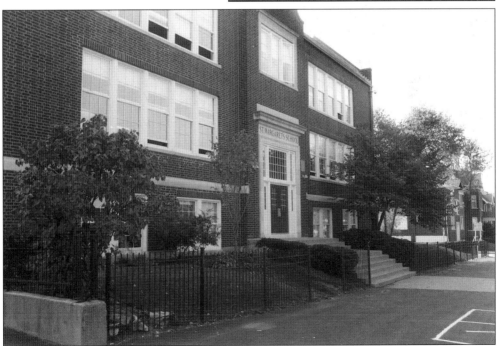

Here is the first school that the St. Margaret of Scotland's parish established in the 3900 block of Castleman Avenue.

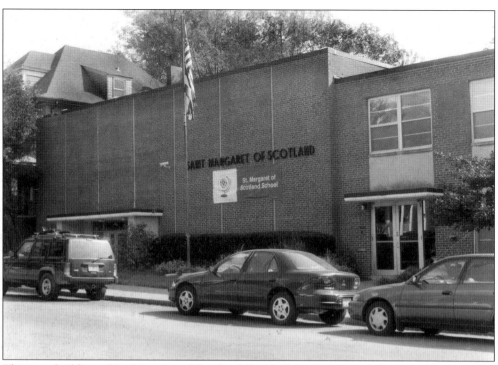

This new building of St. Margaret of Scotland Parish School was erected as an addition to the old school pictured above. It stands next to it.

Tower Grove Christian School boasts this rather large building at Magnolia and Tower Grove Avenues. It stands almost kissing the garden itself.

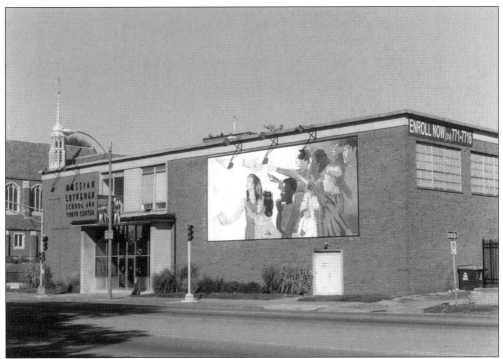

Messiah Lutheran School and Youth Center contains not only a school, but a meeting place where youth are invited to gather. It is located on Grand Avenue directly across from Tower Grove Park.

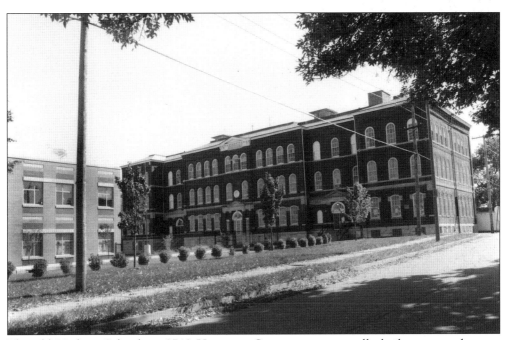

The old Hodgen School, at 2748 Henrietta Street, was eventually built next to the new school (left).

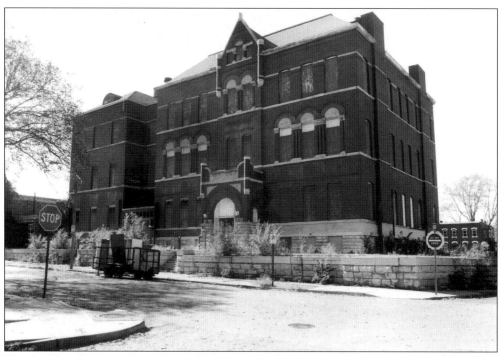

This building that once housed the old Grant School, at 3009 Pennsylvania Avenue, has been put up for sale by the Public School system.

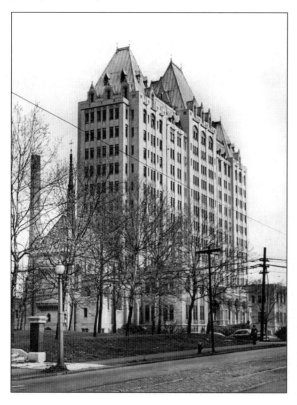

This photo provides us with a 1950s view of Firmin Desloge Hospital. This institution has been tossed about since that date—owned for generations by the Jesuits as their teaching hospital, it was recently sold to the Tenet Group. Of course, the hospital has been added to and remodeled since the 1950s.

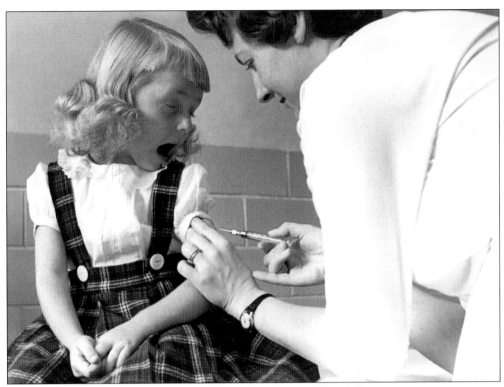

A St. Louis University Hospital nurse gives a vaccination. (*c.*1950.)

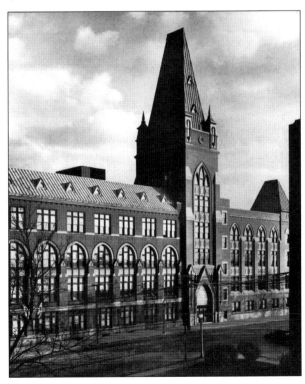

Here, we see the new addition that has been added to Schwitalla Hall of the St. Louis University Medical School. (*c.* 1948.)

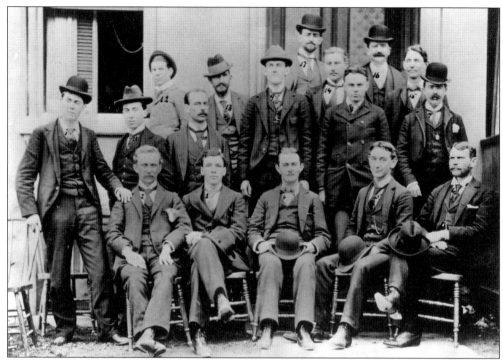

This is a 1896 photo of the dental department of the Marion Sims Medical College. This department was later absorbed by St. Louis University.

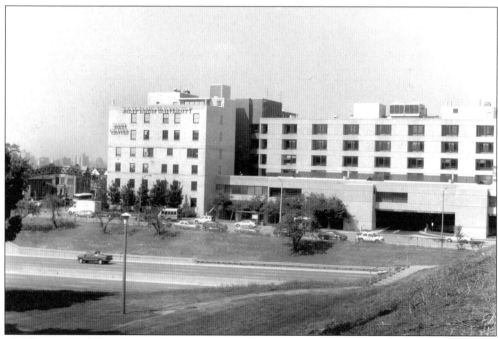

The former Incarnate Word Hospital, at 3545 Lafayette Avenue, has been remodeled as a hotel with some St. Louis University school departments added. Thoroughly restored, the unit is called the Salus Center.

Nine
MISSOURI SCHOOL FOR THE BLIND

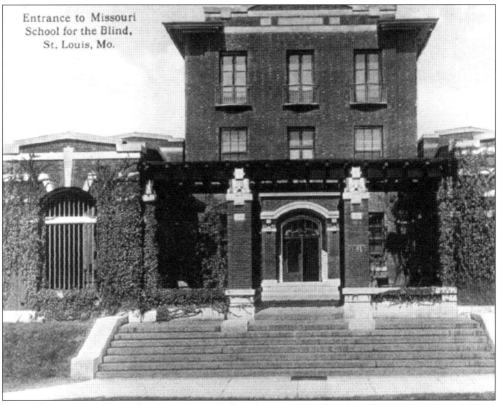

Entrance to Missouri
School for the Blind,
St. Louis, Mo.

As we have seen, the garden area flourished with its many schools and training centers. Most important of all in this category was the celebrated Missouri School for the Blind. Founded as early as 1851 as a private charitable enterprise, it became state operated in 1855. Noted for its pioneer work in the education of the blind, the school was the first in the nation to adopt the Braille system. The school has had many homes. Here its shown at its 1906 residence, where it had moved from after leaving the old Beauvais mansion.

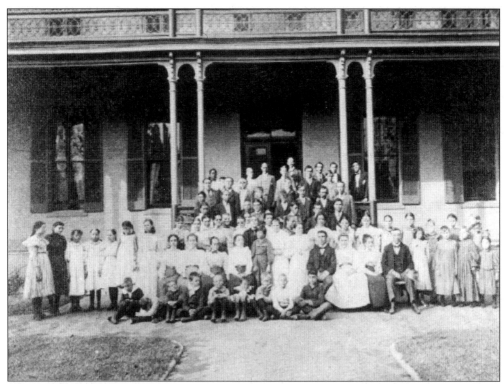

These students pose for the camera in the early 1900s.

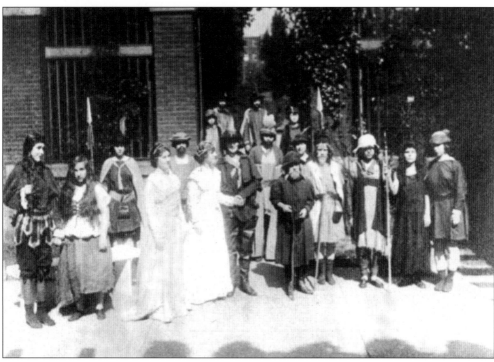

"As You Like It," was comprised of a blind cast and directed by Mrs. Sankey in the spring of 1916.

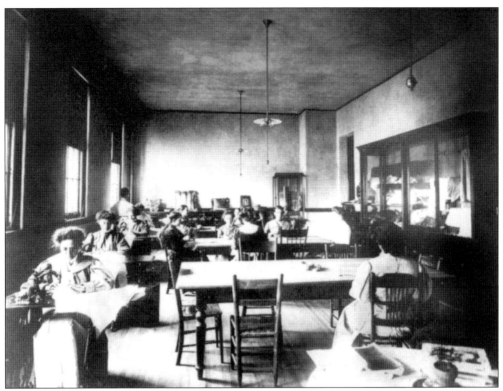

Here, we see these students at work in a sewing class at the turn of the century.

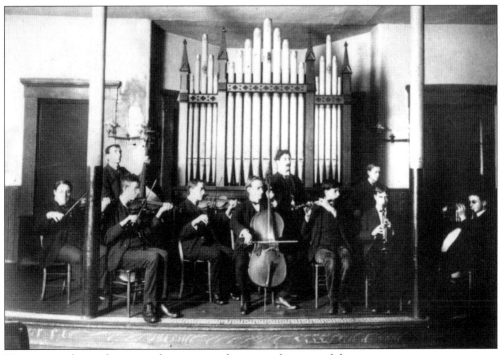

Here are students playing in their own orchestra at the turn of the century.

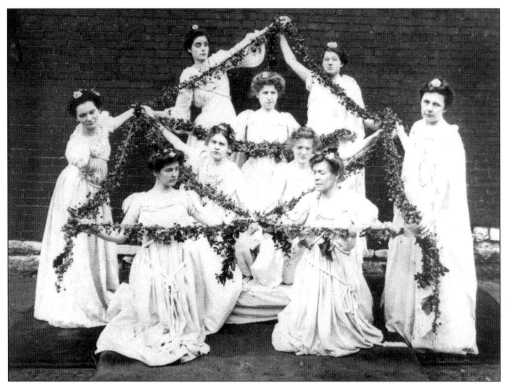

These students are creating an arabesque in a school entertainment. (*c.* 1890.)

Two students have a music lesson in 1911.

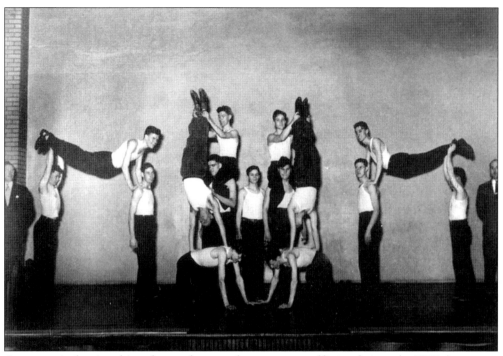

A gymnastic feat is achieved as students perform an array of living figures. (*c.* 1930s.)

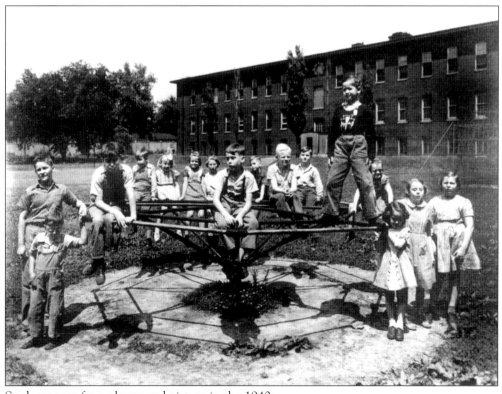

Students pose for a playground picture in the 1940s.

A youngster listens carefully as his instructor prepares him for some chore in this shop class.

Here, an instructor is shown with a student in the school's swimming pool.

Ten
RENEWAL AND CHANGE

It is not surprising then that our Garden District, the expanse that we have been describing of desirable parks, handsome houses, multiple schools, and churches, should be experiencing a renaissance of sorts. After a period of deterioration, the Garden District has suddenly begun to bloom again. As we have noted, despite its partial decline, the district had retained a good deal of its original beauty. As a matter of fact, such major segments such as the Missouri Botanical Garden and Tower Grove Park have been the major factor in this awakening. However, what was needed for others was a slight nudge of sorts. Restoration and rehabbing has become the order of the day. People are returning to the city to rebuild their old town and the Garden District is being seized upon as particularly desirable. There has been a boom reaction in commercial and real estate activity. This activity has not been limited to the commercial renewal of Grand Avenue, with its abundance of Asian shops and restaurants, but has extended to the restoring of homes and stores throughout the Garden District. Homes such as this Victorian structure on Geyer Avenue, which was erected in the 1870s, are being carefully restored to their original designs. This home is located in the Compton Hill area. More modest dwellings are also being refurbished throughout the community. New buildings have also been going up.

Consider this house on Ohio Avenue near Gravois Avenue—renewal continues at all levels. This ancient dwelling from the early 19th century is at last being renovated by its owner.

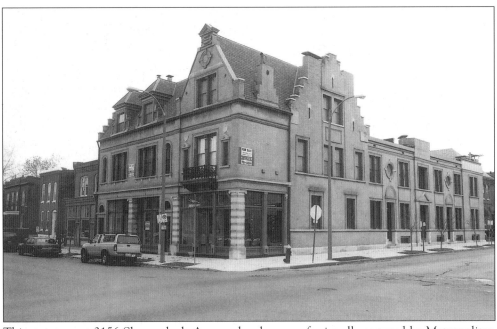

This structure at 3156 Shenandoah Avenue has been professionally restored by Metropolitan Design and Build. It was originally created by the famous Ernst C. Janssen, who, as we have seen, was a popular architect in fashionable Compton Heights. The date of original construction was 1894.

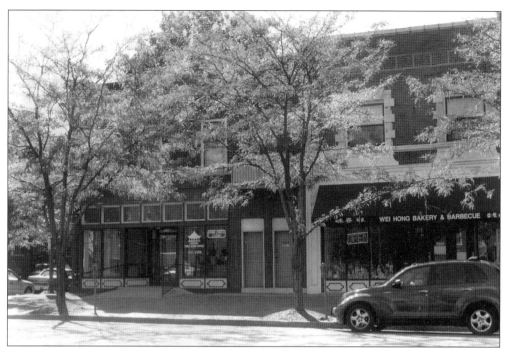

Here we get a sense of growth and prosperity that has characterized South Grand Avenue since it has become the center of new commercial life and customers. New shops have been opened and old ones renovated.

The greatest factor contributing to this new prosperity has been the influx of Thai, Chinese, and other Asian eateries and shops that have arrived on the street. All of this activity has added an international dimension to the street that it has never before experienced.

Pictured here is one of the two bookstores in the area. The other is the well-known Dunaway Books, one of its directors is a noted authority on literary letters and antiquities.

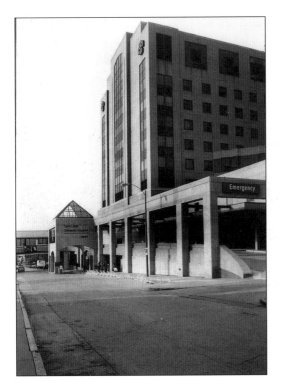

This shot captures the enormous rebuilding and renovation program that has reshaped the former Firmin Desloge Hospital, part of the St. Louis University Medical Center.

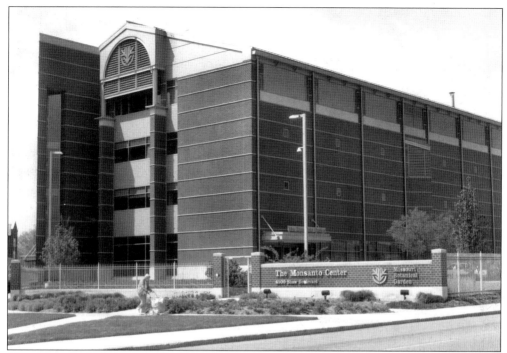

This important addition to the area is the new Monsanto Center, which promises a new era in plant technology for the United States and the international community. Although this structure is affiliated with the Missouri Botanical Garden, it stands on Shaw Avenue, a short distance from the Garden.

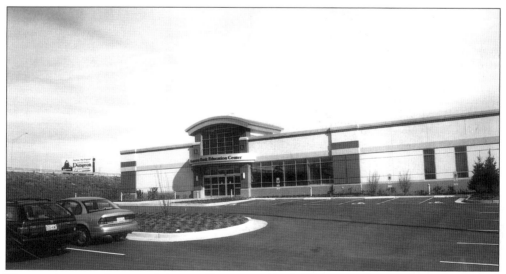

The newly opened, state-of-the-art Commerce Bank Education Center, located at Shaw Avenue and Kingshighway Boulevard, is designed to promoted math and science instruction to students of all ages.

Thus we have come full circle. We began with the efforts of Henry Shaw to make life richer and more worthwhile for St. Louis citizens, and we end with this new Center conceived in the same Shaw spirit.

BIBLIOGRAPHY

Bartholomew, Harland and Associates, "Dream by the Gravois," St. Louis, Mo. 1976. Christensen, Lawrence and Others, "Dictionary of Missouri Biography, " University of Missouri Press, 1999.

Compton, Richard J. and Camille N. Dry, "Pictorial St. Louis," 1875.

Faherty ,William B.,.S.J., "Henry Shaw: His Life and Legacies," University of Missouri Press, Columbia, Mo., 1987.

Fox, Tim, ed. "Where We live: A Guide to St. Louis Communities," Missouri Historical Society Press, St. Louis, 1995.

Gaines, Judith and Cindy West, "Walking St. Louis," Falcon Press, Helena, Montana, 1999.

Hannon, Robert E, ed., "St. Louis: Its Neighborhoods and Neighbors, Landmarks and Milestones, St. Louis Regional Commerce and Growth Association, St. Louis, 1986.

Rubright, Robert, "Walks and Rambles in and around St. Louis," Backcountry Publications, Woodstock, Vermont, 1995.

Stiritz, Mary M, "Historic Churches and Synagogues," St. Louis Public Library,and Landmarks Association, St. Louis, Mo., 1995.

Scott, James F and John Knoll, "Henry Shaw: The Good Neighbor," (a video tape), St. Louis, Mo., 2002.

Toft, Carolyn Hewes and Jane Molly Porter, "Compton Heights A History and Architectural Guide," Landmarks Association of St. Louis, Inc., St. Louis, Mo., 1984.

"Tower Grove Park Story," Tower Grove Park, 4255 Arsenal, St. Louis, (n.d.)